chalk art & LETTERING 101

AN INTRODUCTION
TO CHALKBOARD
LETTERING, ILLUSTRATION,
DESIGN, AND MORE!

BY SHANNON ROBERTS & AMANDA ARNEILL

paige tate
& CO.

Written and Illustrated by Shannon Roberts and Amanda Arneill

ISBN: 9781944515614

Printed in China

10 9 8 7 6 5 4 3 2 1

This Book belongs To

Table of Contents

Getting Started

Design

Illustration

Lettering

Shannon is a wife and mother with a heart for Jesus, whose passions include family, friends, fitness, and warm, sunny days. When she's not drawing on a chalkboard, you can find her chasing her kids around or in her happy place at the gym.

Shannon has been drawing and lettering professionally since 2014, when she first opened her Etsy shop called The White Lime. There, she sells prints and cards of her hand-drawn chalk art and lettering designs. She also works as a freelance artist for several companies that are licensed to reproduce and sell her work. Through them, her art has been sold in popular stores including Nordstrom, Hallmark, Hobby Lobby, and HomeGoods.

While she holds a master's degree in education, Shannon has had no formal art training and is self-taught as an artist. She finds inspiration in her day-to-day experiences, and hopes to glorify God with each opportunity she's blessed with.

You can learn more about Shannon and her work by visiting her website: thewhitelime.etsy.com.

@shannonroberts19

Amanda is an established hand-lettering artist and instructor who has inspired many all over the world through her online courses to pick up their pens, pencils, chalk, and more, and just start lettering! As a mom of two, a wife, and the owner of a successful business, Amanda knows the importance of slowing down in this busy world and taking the time to create something beautiful for yourself.

Addicted to all things lettering, irrationally excited by new pens and art supplies, and determined to spend as many working days as possible in sweatpants, Amanda has built a dedicated and ever-growing following of lettering lovers.

Amanda combines her professional training and over a decade of experience as an elementary and high school educator with her passion for lettering and learning in order to engage and challenge her students. She's created a humor filled online presence and is well-known for her unique and distinguishable style, as well as her ability to teach others to develop their own style.

Find out more about what you can learn from her at amandaarneill.com.

@amandaarneill

Welcome

to the world of chalk art and lettering! Are you a chalk novice looking to have some fun? Do you have some experience with chalk and want to continue to develop your skills? Do you consider yourself a chalk expert? Whatever your skill level, there is something for you in this book! *Chalk Art & Lettering 101* provides instruction and inspiration to enhance your skills and abilities.

This book is broken into four sections. In "Getting Started," you will learn the basics of making and seasoning your own chalkboard. "Lettering" introduces various alphabets and lettering styles, including serif, sans serif, cursive, and calligraphy. You will also learn how to add depth and dimension to your letters. "Illustration" guides you through the processes and steps involved in creating beautiful and charming chalk art, including banners, flowers, feathers, and butterflies. In "Design," we teach you tips and tricks for how to set up and embellish projects. Finally, you will learn how to put everything you have learned together in a series of charming projects. Combine beautiful lettering with gorgeous illustrations, and you will be creating jaw-dropping chalk masterpieces in no time. Are you ready to chalk? Let's get started!

Ruler

Cotton Swab

Microfiber Cloth

Dust Cup

Sharpener

Chalk

Felt Eraser

Pencil Eraser

Tools

Air Blower: This special tool isn't required, but it will be a huge help if you are tired of blowing chalk dust off of your board. The air blower can be used to blow away chalk dust that is sitting on top of your chalkboard designs, but it can also be used to blow away bits left behind from creating shadow and depth with your pencil eraser. This way, you don't have to waste your breath, but can simply use this tool to blow it all away!

Chalk: Use this to create beautiful chalkboard art and lettering!

Cotton Swab: Use this to blend the chalk into your chalkboard background, add shadows, and create "shiny" vintage letters.

Dust Cup: Use this to collect dust that is created when sharpening chalk.

Felt Eraser: Use this to "erase" and add chalk dust to your chalkboard.

Microfiber Cloth: Use this to fully erase your designs. Between all of your erasing tools, this one will leave the least amount of dust.

Pencil Eraser: Use this to add depth and dimension to your designs. You will get your darkest shadows from the pencil eraser. It can also be used to clean up small mistakes.

Ruler: Use this to draw straight lines, perfect shapes, and guidelines.

Sharpener: Use this to sharpen your chalk. A simple pencil sharpener with a hole big enough for a piece of chalk will do the trick!

making YOUR CHALKBOARD

With so many chalkboard paints and materials available on the market, it can be a bit overwhelming to decide which ones are the best for your needs. You can always purchase a pre-made chalkboard online or at your local craft store, but in our opinion, the best chalkboards are made at home!

Different paints and materials will provide different finishes. If you opt to use chalkboard paint, we recommend that you use a paint roller with a foam cover to apply the paint. This will give you a smoother finished product. (A paint brush can be used to fill in spots as needed!)

If you want to create a perfectly smooth chalkboard surface that allows you to make those clean, crisp chalk lines, then chalkboard spray paint is the way to go! It's quick, easy, and has a beautiful finish that allows your chalk to glide across the surface of your chalkboard.

Whether you use chalkboard paint or chalkboard spray paint, you will likely need several coats to completely cover your board.

Once you have chosen paint, you will need to purchase hardboard. Most local hardware stores have a lumber section where hardboard can be found. Hardboard ranges in thickness from 1/8" to 3/16" and has a very smooth surface that is perfect for chalk paint! The smallest sizes are usually sold as 2x4s, but an employee can cut down the board to your preferred size at little to no extra charge.

Now that you have your materials, it's time to paint your board! Wait a couple of days for the paint to fully dry, season your board, then you are ready to start chalking!

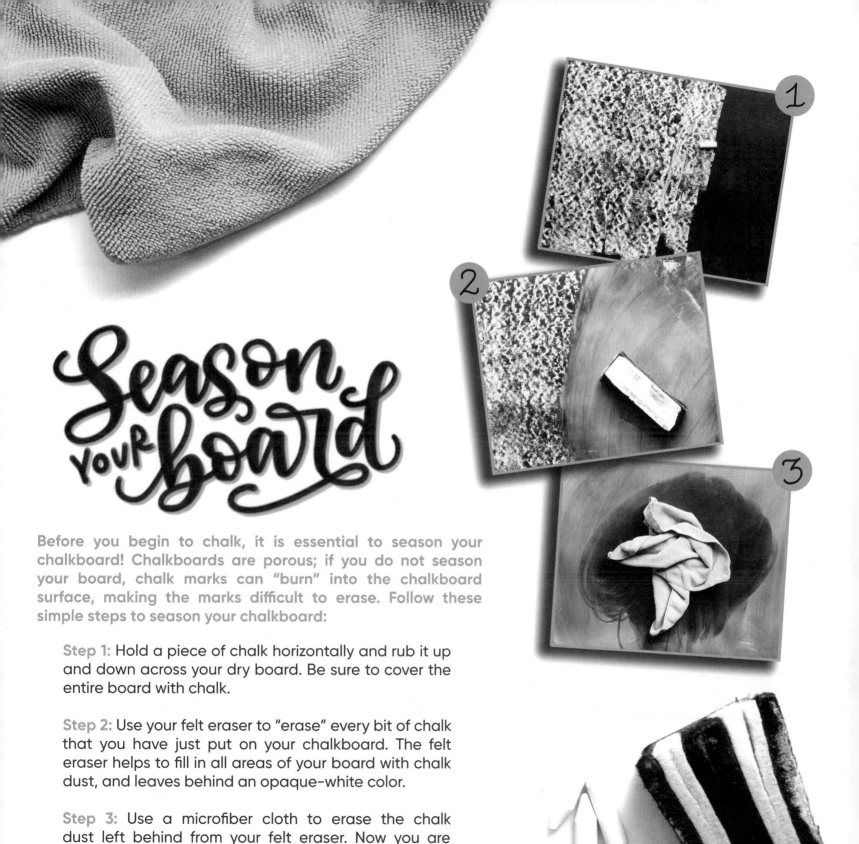

Season your board

Before you begin to chalk, it is essential to season your chalkboard! Chalkboards are porous; if you do not season your board, chalk marks can "burn" into the chalkboard surface, making the marks difficult to erase. Follow these simple steps to season your chalkboard:

Step 1: Hold a piece of chalk horizontally and rub it up and down across your dry board. Be sure to cover the entire board with chalk.

Step 2: Use your felt eraser to "erase" every bit of chalk that you have just put on your chalkboard. The felt eraser helps to fill in all areas of your board with chalk dust, and leaves behind an opaque-white color.

Step 3: Use a microfiber cloth to erase the chalk dust left behind from your felt eraser. Now you are ready to start chalking!

the GRAYSCALE

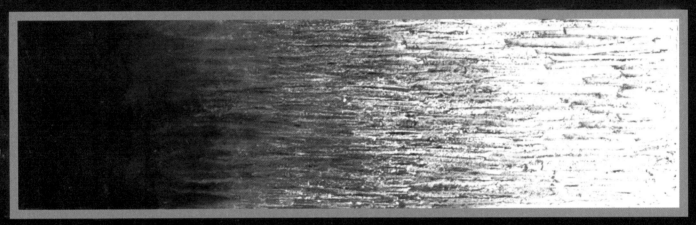

Shadow　　　　　　　**Midtone**　　　　　　　**Highlight**

It is essential to understand the chalkboard grayscale (above) prior to beginning any chalk lettering or illustration project. The grayscale represents all of the colors you will be able to achieve using regular chalk and a chalkboard. Since a chalkboard is black (or dark in most cases), and chalk is generally white, you will be creating your work on a grayscale rather than with color. Colored chalk will change this, but your shadows, midtones, and highlights will all be achieved the same way.

flip the script

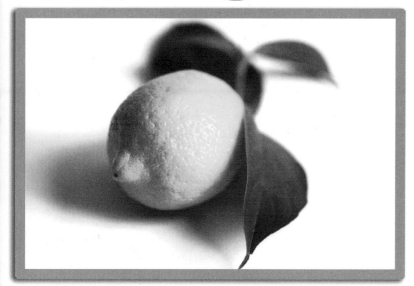

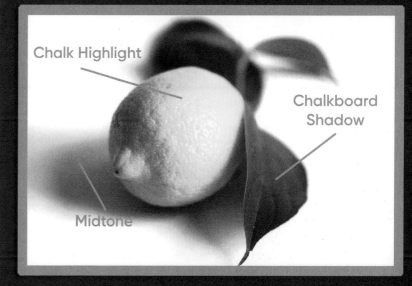

Chalk Highlight

Chalkboard Shadow

Midtone

When drawing on a white surface, one would normally add shadows and midtones to their image. This is because the white surface acts as a natural highlight in your drawing or lettering. Therefore, you must add the shadows and midtones with your drawing tool. On a white surface, the tool you use will naturally be darker, so that it can be seen. In a chalk drawing or lettering piece however, the exact opposite is true. The chalkboard background acts as a natural shadow color. This means that you must add the highlight and midtone shades with your chalk. It can be a little tricky at first trying to flip the script and reverse what one would normally draw or write on a white surface, but the more you practice, the easier this skill will become.

In the image above, the lemon is shown in grayscale. In chalk drawings, this is how you want to picture your lettering and illustrations prior to beginning a new piece. The dark areas of the image will show up naturally, as seen in the leaf. The lighter areas of the image are what you will need to focus on actually drawing. The midtone and highlight shades can all be created from chalk and chalk dust. If you were to draw the actual lemon in the image, you would use both highlight and midtone colors. The harder you press, the whiter the chalk will appear against the chalkboard surface (creating your highlights), while the lighter you press, the darker your chalk will write or draw (creating your midtones).

Midtone

Highlight

Ours is a
REal Life
love story

Shadow

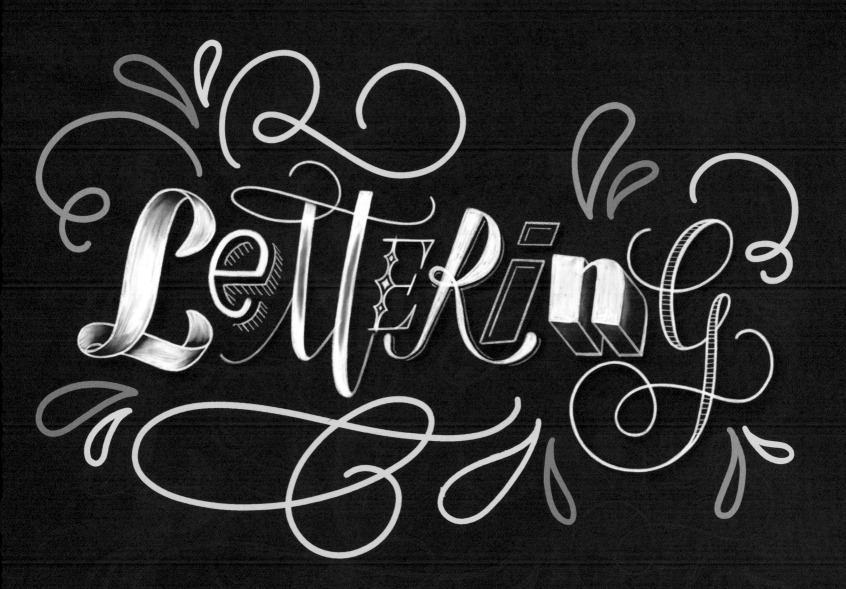

CHALKBOARD LETTERING

hairline · serif · apex · STEM · BOWL · ASCENDER · UPPERCASE · ear · COUNTER · CROSSBAR · X-HEIGHT · BASELINE · ARM · STEM · SHOULDER · STEM · CROSS STROKE · lowercase · FINIAL · SWASH · DESCENDER · CAP height

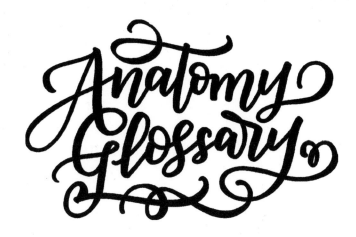

Anatomy Glossary

Apex: the highest point of the uppercase A

Arm: a horizontal stroke that is not connected on at least one end

Ascender: the part of a lowercase letter that extends above the x-height

Baseline: the imaginary line where letters stand

Bowl: the curved stroke that encloses the counter of a letter

Cap Height: the height of the capital letters starting from the baseline to the top of the capital letters

Counter: a fully or partially enclosed space within a letter

Crossbar: horizontal stroke connected on both ends

Cross Stroke: horizontal line that intersects the stem

Descender: the part of a letter that descends below the baseline

Ear: decorative flourish on the upper right side of "g" or "r"

Finial: the curved end of a letter

Hairline: the thinnest line of a letter, as seen in calligraphy

Lowercase: the smaller form of letters in the alphabet

Serif: decorative lines added to the end of a letter's stem

Stem: the vertical stroke of a letter

Shoulder: a curved stroke that begins from the stem

Swash: a decorative stroke, as seen in calligraphy

Uppercase: capital letters that are used to begin sentences and proper nouns

X-height: the height of the lowercase letters—specifically the x; does not include ascenders or descenders

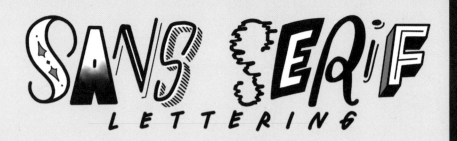

Sans serif letters are simple and clean, and don't have added line ends (these line ends are called serifs). Sans serif letters can be used in any number of ways: stunning headlines, smaller text, or whenever you want to feature simple, clean, and modern lettering.

It is important to master the shape of each letter in the sans serif alphabet because this alphabet is also the building block for serif letterforms.

Sans serif letters are crisp and clean; this can be tricky to achieve with chalk. When you are drawing sans serif letters, focus on creating clean lines. Be sure you are using sharp chalk, as this will help with precise line placement. Don't be afraid to use guidelines to direct your strokes!

Step 1: Lightly sketch a simple letter. Use this as a guide for creating your sans serif letter.

Step 2: With a clean, single stroke (using sharp chalk!), trace one line of the letter slightly to the right of the guideline. Then repeat this on the left side of the guideline. This allows you to evenly create broad chalk lines while maintaining the width of the line.

Step 3: Make sure your chalk is still sharp. Create crisp ends on the top and bottom of your lines, and at places where curves join a straight line.

Step 4: Use your eraser to darken to the right of each of your lines; this creates a shadow effect.

All serif letters are based off of this letterform. Once you have mastered it, try changing it up by adding shadow lines, erasing areas inside of the letters, or adding details, outlines, or 3-D effects.

Each lettering section in this book comes with sample alphabets, but you can also refer to pages 48-51 for more inspiration!

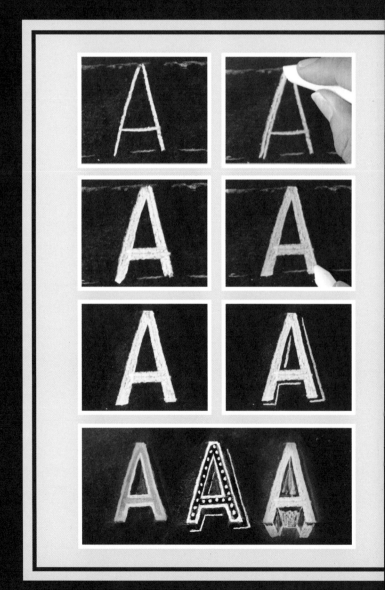

Step 1:
Draw a slightly lopsided, playful letter.

Step 2:
Mirror the lines in your letter with parallel lines.

Step 3:
End the letters with joining lines.

Step 4:
Color in the letter with chalk.

Step 5:
Add a shadow and interior detail.

Step 1:
Draw a wide version of a letter.

Step 2:
Widen the letter on each side and erase the initial guide letter.

Step 3:
Add chalk to highlight the top and bottom of the letter.

Step 4:
Use your finger to blend the chalk, keeping away from the center.

Step 5:
Add a shadow behind the letter.

Serif lettering is based on the sans serif letterforms, but with serifs attached. Remember, serifs are the extra ends on the lines; these give the letter a more formal appearance.

Step 1:

Draw the traditional sans serif letter.

Step 2:

Place horizontal serifs off the ends of your letters. (Refer to the example alphabets if you need to be reminded of the placement for serif lines.)

Step 3:

Complete the serifs by adding vertical serif lines. When you add these, be mindful of the size and scale. Generally, serif lines in the middle should be smaller than the outer serifs.

Step 4:

Add thickness to your downstrokes so that the line is consistently thick all the way down.

Step 5:

Use your eraser to remove the chalk dust, and create a dark shadow behind the letter.

Step 6:

Once you have mastered the basic serif alphabet, you can add variety: change the angle or curve of the serif, or try adding detail to the inside of downstrokes.

ABCDEFGHIJKLMN
OPQRSTUVWXYZ

ABCDEF GHIJKL MNOPQR STUV WXYZ

Step 1:
Draw your regular sans serif letter.

Step 2:
Add serif tails that have a curve to them on the terminus of each line.

Step 3:
Thicken up your down-strokes with lines that curve out slightly at the top and bottom.

Step 4:
Color in the space and smooth out your edges.

Step 5:
Add a shadow and then trace the outer edge of the shadow with very sharp chalk.

Step 1:
Draw your letter very lightly.

Step 2:
Trace around the down-strokes, and over the cross strokes.

Step 3:
Using a very sharp piece of chalk, color in just the very center of the letter.

Step 4:
Ensure there is a consistently thin line around the interior section.

Step 5:
Add a shadow to the outside of the letter.

ABCDE
FGHIJ
KLMNO
PQRST
UVWX
YZ

a b c d e f g
h i j k l m n
o p q r s t u
v w x y z

Step 1:
Draw a simple serif letter.

Step 2:
Thicken the downstrokes with a second stroke.

Step 3:
Color in the area in between the two strokes.

Step 4:
Create a shadow by using a pencil eraser to remove the space behind.

Step 5:
Using a very sharp piece of chalk, add tiny dashes around the erased shadow.

Cursive lettering to Calligraphy

The cursive penmanship that you learned back in elementary school is about to pay off since it is the basis of the calligraphic alphabet. The thing that sets these two apart is that regular cursive (also known as the monoline alphabet) consists of lines that are all the same weight, whereas the calligraphic alphabet has areas called "downstrokes" where the lines are thicker.

Step 1:
Write the letters for your word using the cursive alphabet. Draw your letters wider than you might normally, because you will be adding width to some of the lines.

abcdefg
hijklmno
pqrstuv
wxyz

Step 2:
Draw in a second downstroke line, leaving adequate space between lines. Downstroke width should be consistent from letter to letter, maintaining the same thickness all the way from the top of the stroke to the bottom.

abcdefg
hijklmno
pqrstuv
wxyz

In traditional calligraphy, these thicker lines are created by putting more pressure on the pen, but when you work with chalk, the thicker lines are created by drawing a second line beside the first, and filling in the space between the two.

The next fourteen pages will guide you on your chalkboard calligraphy journey.

Step 3:	Step 4:
Fill in the letters. As you see here, calligraphy is visually striking because it involves strong, thick lines, as well as lighter lines.	Finish the letters with ombré or a shiny effect (see pages 44-47), and add some shading to make your letters stand out.

calligraphy

Take your time as you make each letterform! Each box guides you through converting a cursive letter into a calligraphy letter.

- The blue dot is where you begin the letterform.

- The arrows guide the direction to go.

- One blue dot means that the letter can be done in one stroke. More than one blue dot indicates that you will lift your chalk to begin a new stroke.

Start with a cursive letter, add dotted lines, trace and fill the dotted lines, and finally, fill in the letter. You're on your way to beautiful chalk calligraphy!

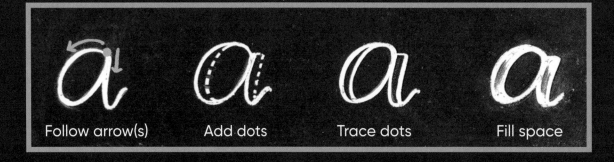

Follow arrow(s) Add dots Trace dots Fill space

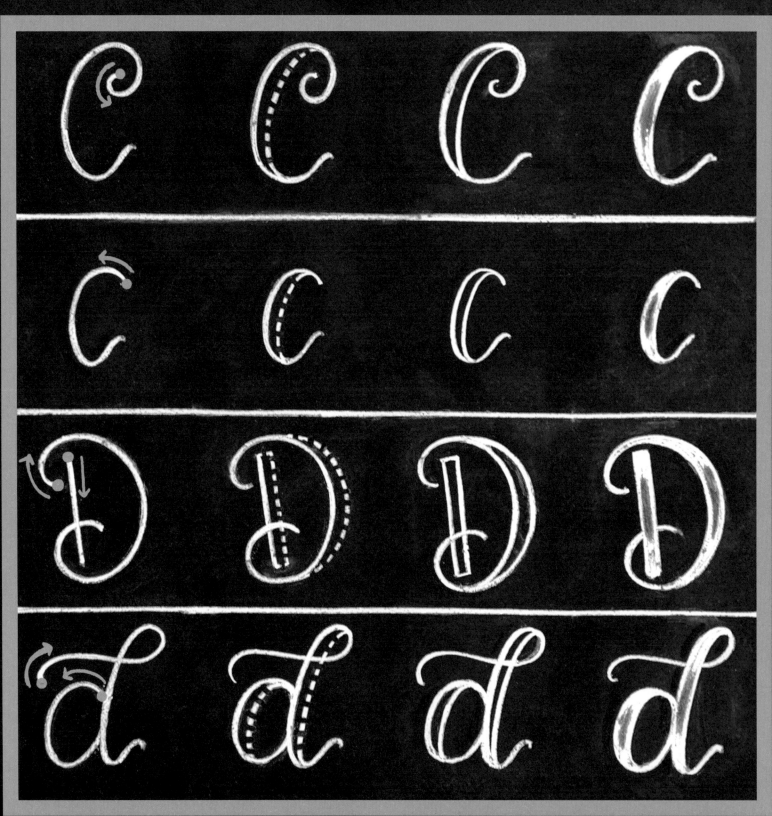

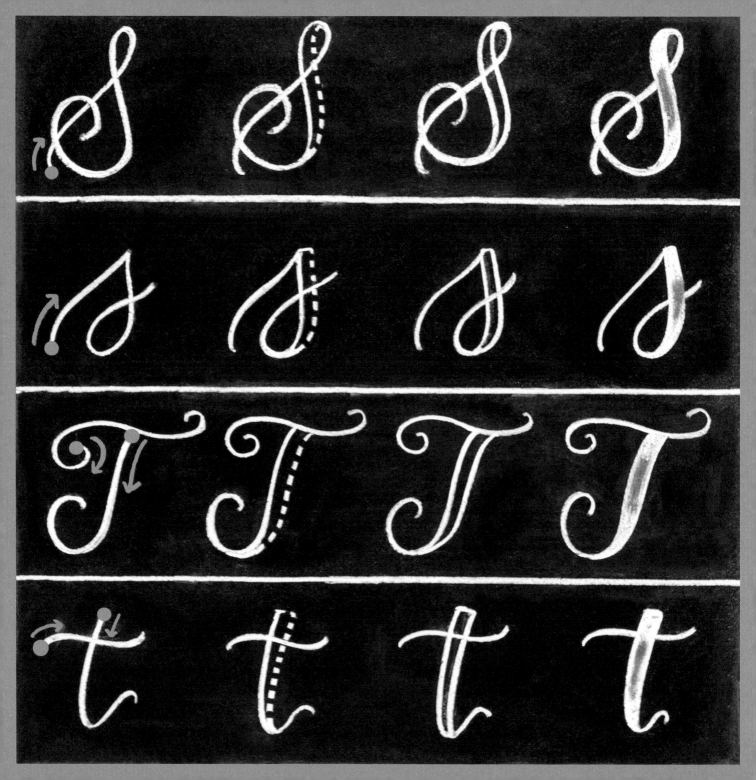

LETTERS

Step 1:
Draw your double-line serif letter, making it wide enough to hold the shiny midtone area in its center.

Step 2:
Color in the letter completely with full highlight (full pressure of your chalk).

Step 3:
Keep your lines and edges crisp by redrawing the outline if necessary.

Step 4:
With a dry cotton swab, smudge over the middle area of the letter (keeping the full strength of chalk at the top and bottom of the letter). You can also smudge on round areas of curves, anywhere that light would reflect.

Step 5:
You may need to soften the transitions between the full-strength chalk areas and the new mid-tone areas. Switch back and forth between chalk and smudging until you achieve a subtle gradient on the edges of the midtone.

Step 6:
Add a shadow to your letter by tracing one side of your letter with an eraser. This step is especially important to create extra drama on your shiny letters. After adding your shadow, you may need to retrace the outside of your letter to ensure crisp, clean edges.

THERE'S

ALWAYS

a

BRIGHT
SIDE

Step 1:

To create an ombré effect, first sketch your letter.

Step 2:

Use that initial sketch to create the outline for your letter. Add a very light midline to guide your ombré coloring.

Step 3:

Color in the entire letter very lightly, using the faintest chalk strokes possible. This will be your midtone color base.

Step 4:

Choose to work either above or below the midline, and color the letter with full chalk pressure. This creates a letter with one half in white and the other in gray.

Step 5:

Where the two join, very gently build up the strokes so there is a gradient effect between the two chalk saturations. In other words, there should be a natural transition from white to gray (rather than an abrupt, hard line change from one to the other).

Step 6:

Using a microfiber cloth, very gently remove the sketched midline. Use your eraser to draw in a shadow behind your letter. Touch up any parts of the letter as needed.

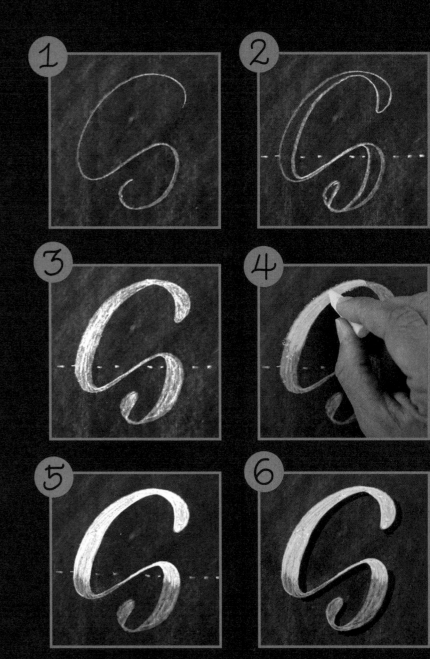

Alphabet Mix-Up

a A A A B B B B

C C C C D D D D

E E E E F F F F

Nn Nn O o o O
Pp Pp P Q q q
R R R R S S S
T t t T

Mixing letters and font styles adds variety and fun to your chalk art and lettering designs. Practice by choosing letters from the provided examples, and mix them up to create something unique!

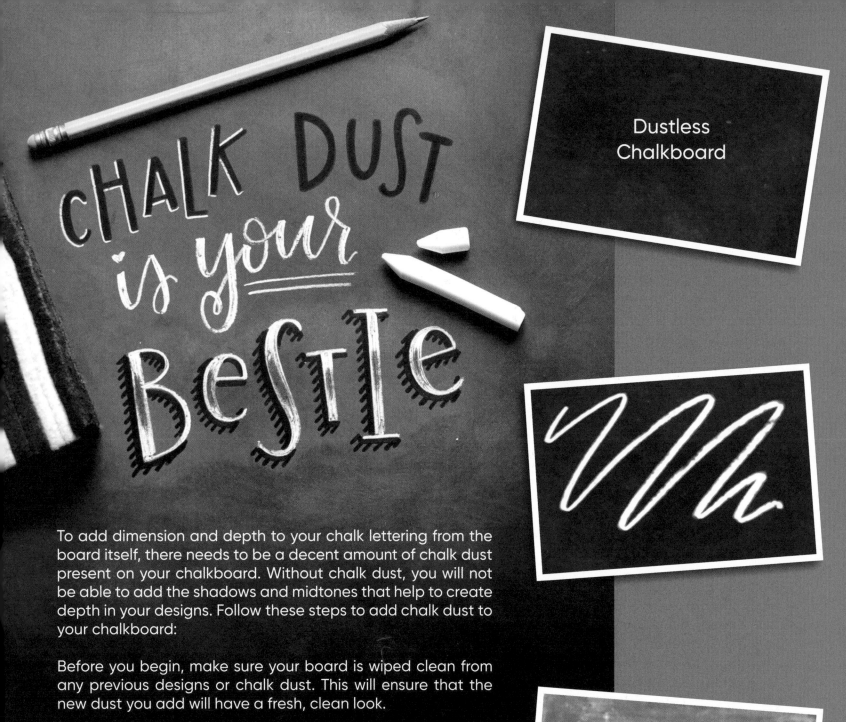

CHALK DUST is your BESTIE

Dustless Chalkboard

Dust-covered Chalkboard

To add dimension and depth to your chalk lettering from the board itself, there needs to be a decent amount of chalk dust present on your chalkboard. Without chalk dust, you will not be able to add the shadows and midtones that help to create depth in your designs. Follow these steps to add chalk dust to your chalkboard:

Before you begin, make sure your board is wiped clean from any previous designs or chalk dust. This will ensure that the new dust you add will have a fresh, clean look.

Use your chalk to scribble all over the areas of your board where you want to add chalk dust. If you want your entire board covered in dust, scribble over the entire board.

Use your felt eraser to erase the entire area you want covered in chalk dust. You will know you have achieved enough chalk dust when your board has a light gray midtone color, and your finger leaves a fingerprint.

The lettering examples to the right show the difference that chalk dust can make in your lettering pieces.

The first image shows lettering on the chalkboard when there is no dust present. Without dust, there is almost no way to add dimension and depth from the board itself.

In the second piece, the lettering is shown on a dusty surface. However, no shadowing or midtones have been added. The lettering looks almost transparent against the dust-filled chalkboard.

In the third image, shadow elements have been added using a pencil eraser. The shadows are drawn in clean, distinct lines, which make the lettering pop off the board.

In the fourth and final image, the same shadow elements are present. However, they have been softened and blended into the midtone chalk dust color using a finger and a cotton swab. This gives the shadow a softer, more natural finish.

CHALK *dust*

No Chalk Dust

CHALK *dust*

Chalk Dust + No Shadow Elements

Pencil Eraser

CHALK *dust*

Chalk Dust + Hard Shadow Elements

Cotton Swab

CHALK *dust*

Chalk Dust + Softened Shadow Elements

DIMENSIONAL LETTERS

Two-Dimensional (2-D)
- **Flat**
- **Length & Width**
- **No Depth**

Three-Dimensional (3-D)
- **Depth**
- **Length, Width, & Height**
- **Thickness**

While chalk dust can be used to bring depth and dimension to your designs, you can also give a sense of depth by adding lines to your chalk letters. Consider the examples to the left and right. Letters that are two-dimensional (2-D) will appear flat on your chalkboard. They have length and width, but no depth. In contrast, three-dimensional (3-D) letters have depth and a "thickness" that makes them appear to pop off the chalkboard. There are a number of ways to give letters a 3-D appearance. Before you can do this, however, you must determine which sides of your lettering you want to add depth to. We will explore ways to add a 3-D appearance in the following pages.

2-D **transition** **3-D**

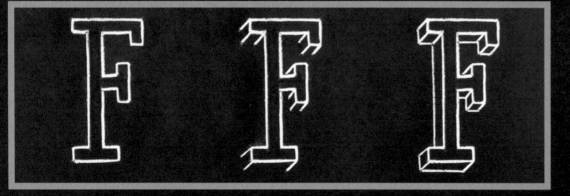

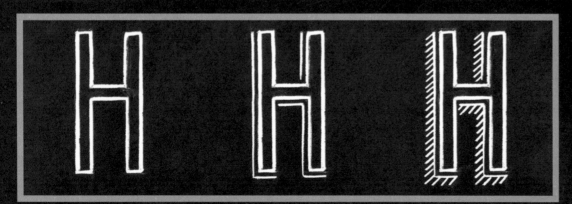

2-D Letter

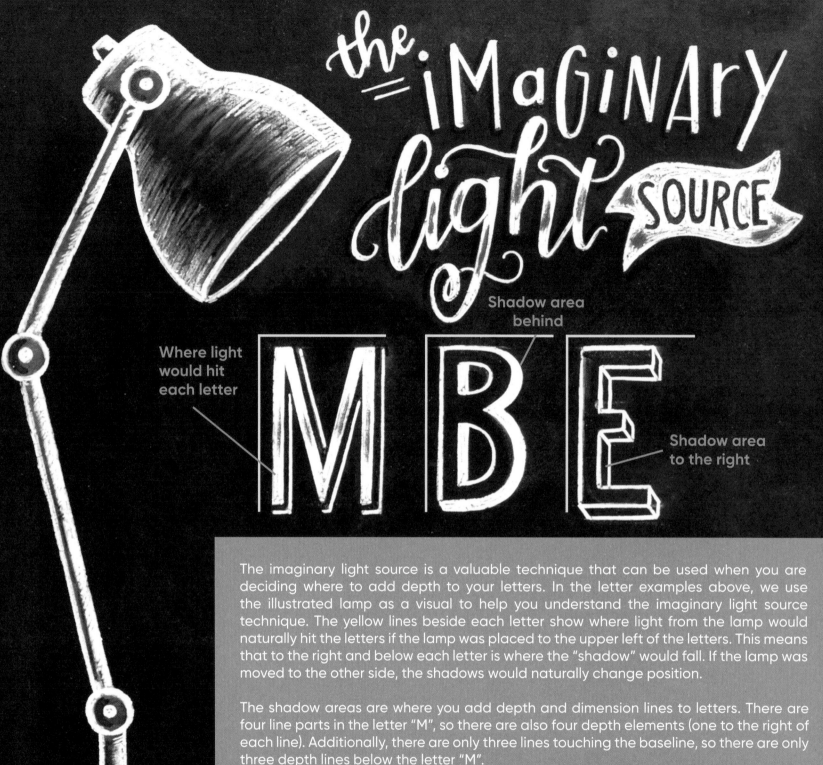

the iMaGiNARY light SOURCE

Where light would hit each letter

Shadow area behind

Shadow area to the right

The imaginary light source is a valuable technique that can be used when you are deciding where to add depth to your letters. In the letter examples above, we use the illustrated lamp as a visual to help you understand the imaginary light source technique. The yellow lines beside each letter show where light from the lamp would naturally hit the letters if the lamp was placed to the upper left of the letters. This means that to the right and below each letter is where the "shadow" would fall. If the lamp was moved to the other side, the shadows would naturally change position.

The shadow areas are where you add depth and dimension lines to letters. There are four line parts in the letter "M", so there are also four depth elements (one to the right of each line). Additionally, there are only three lines touching the baseline, so there are only three depth lines below the letter "M".

The letter "B" has two lines in its formation (the stem, followed by the double curved line). Thus, the depth elements are placed to the right and below both lines of the "B".

The "E" has a stem line and three horizontal lines. Therefore, the depth elements are placed to the right of the stem line, as well as to the right and below each of the three horizontal lines.

You can achieve even greater depth and dimension when you combine 3-D letters and a dust-filled chalkboard.

In the examples below, chalk dust was added first, followed by the letters. Once the 3-D lines were added to each letter, the shadow elements were placed. In the "H" on the righthand side below, the darkest shadow line is directly next to the letter, but as you move further out from the letter, the shadow is softened with a cotton swab to give it a more natural feel.

The shadow elements make it seem as though the letters are actually coming off the chalkboard. This is why shadow placement is so important in lettering—it gives you the ability to add varying degrees of depth to your designs and lettering.

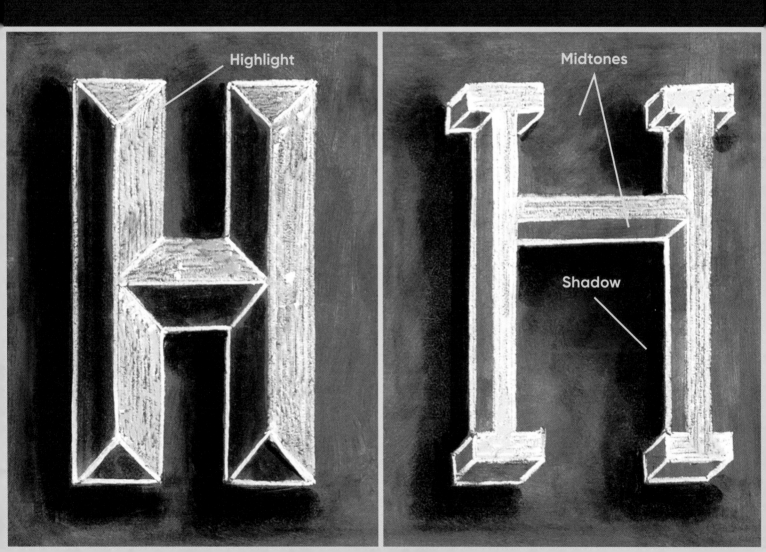

The alphabet to the right shows bubble letters on a dusty surface. The bubble letters alone have depth to them due to the placement of the highlight and midtone.

The dusty chalkboard takes the lettering dimension to another level, because it allows for the addition of a dark shadow illusion that would be impossible without the presence of chalkboard dust.

The higlights, midtones, and shadows work together harmoniously to create a chalkboard illusion that has both depth and dimension. The possibilities are endless when combining 3-D letters and chalk dust!

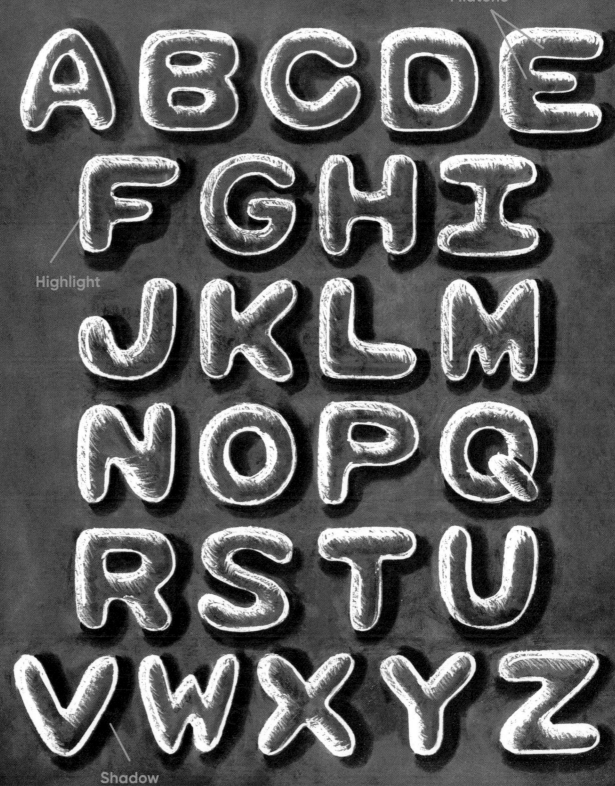

COMPOSITION KEYS

There are some key items to keep in mind to make your lettering cohesive and strong. Pay attention to these elements as you write!

1. *Letterforms*

Some letters are related. In the examples to the right, you see parts like a counterclockwise oval, or a wave stroke. Generally, these elements should be consistent between letters. This consistency helps to make words look more cohesive.

Base Letter

o a d g

Base Letter

n n m h

spacing

a b c d e

2. *spacing*

There should always be consistent spacing between your letters. You can achieve this consistency by defining a set distance from letter to letter. Rather than ending your stroke at the baseline, add a curved upstroke to lead into the next letter. If you do this final upstroke each time, the spacing will be consistent when you place your next letter.

3. *angle*

It is important to keep the angle of your letters consistent, both from letter to letter and between words. Once you choose an angle for your letters, try to maintain the same angle in every letter in your piece. You may have some variety from word to word (especially if your lettering style changes), but when your style stays the same, keep the angle the same, too.

angle angle

angle

height

4. HEIGHT

Certain letters should have similar heights. Letters that go all the way to the cap-line (such as t, l, d, h, k and b) should have a similar height. It can be easy to let one or two letters—especially at the beginning of a word or a sentence—get really large, but watch out for that. One or two really large letters can throw off the scale of the other letters in your piece.

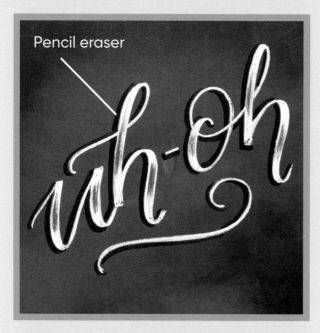

Pencil eraser

To create those dark lettering shadows in your chalk art, you will use your pencil eraser against a dust-filled chalkboard.

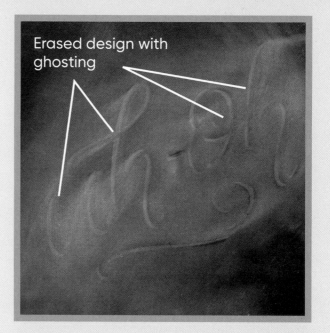

Erased design with ghosting

When you erase a design that used pencil eraser for depth and dimension, there may still be faintly visible marks on the chalkboard.

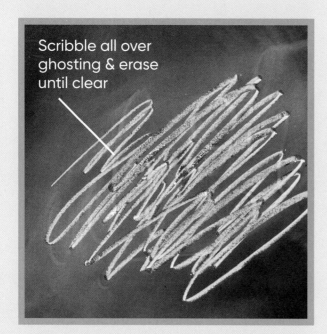

Scribble all over ghosting & erase until clear

Use your chalk to scribble all over the faint designs in your board, then use your felt eraser to erase the design. Repeat these steps until the design is no longer visible.

Ghosting that has been fully erased

Once your board is clear and has an opaque dust-filled finish, you can begin a new design, or simply erase the dust to reveal the dark chalkboard background.

Illustration

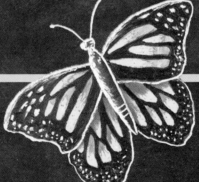

BASIC TO 3D

Start with a dot

Decide on size and measure out with a ruler

Connect the dots

Finally add:

Highlights Midtones

Then blend

Begin by drawing a dot. Use your ruler to measure two inches out from the dot. This will create a four-inch circle. Connect the dots to form your circle, then picture your imaginary light source hitting the image. Add highlights and midtones accordingly.

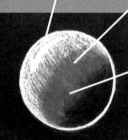

Make one set of horizontal and vertical dots, then connect them

Add dimension lines

Add highlights and midtones, then blend

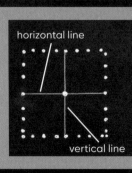

horizontal line

vertical line

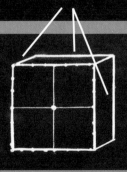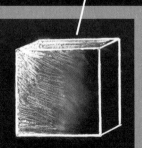

Begin with your center dot, but measure out only two points horizontally, and two points vertically at first. Draw a line that connects both sets of points. Then, use your ruler to make marks on each side of the vertical and horizontal lines. Connect the dots, then add dimension lines. Add depth with highlights and midtones, then blend.

Earlier in the book, the grayscale was introduced. When it comes to your chalk illustrations, the grayscale is very important! Since chalk is white and a chalkboard is typically black, the colors that show up on your chalkboard will fall under the grayscale color values. The brightest whites from your chalk will serve as highlights, grays will be midtones, and black shades will become shadows. It is important to remember to "flip the script" so chalk values can be achieved. Colored images that can be converted to grayscale (like the lemon example on page 15) will help when you are drawing your chalk images. Oftentimes, the highlights, midtones, and shadows will blend into each other.

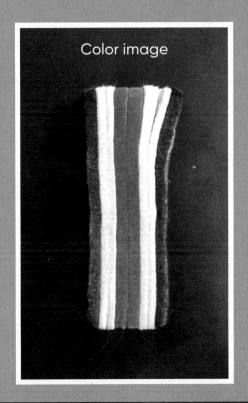

Color image

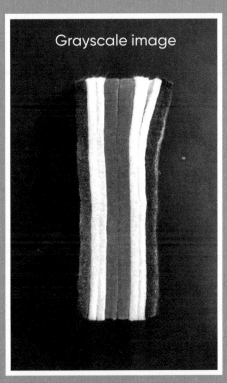

Grayscale image

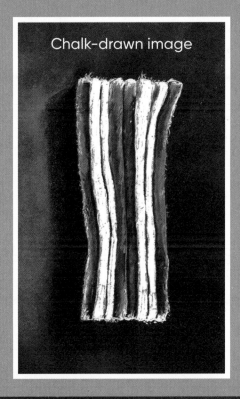

Chalk-drawn image

Blended Midtone

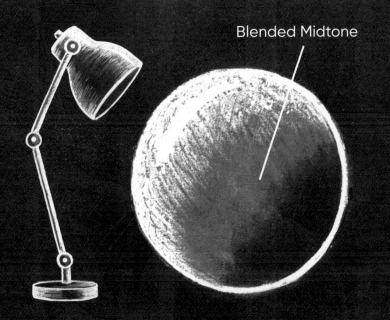

Don't forget to visualize an imaginary light source next to your chalk art illustrations. This can help you determine where to add your highlights, midtones, and shadows in order to give depth and dimension to them. Blending the grayscale color values together will make your illustrations look more realistic. Notice the ball to the left. The gray area shows up as a midtone. This is where a cotton swab was used to soften and blend the highlights into the shadow area.

Borders & Frames

Borders generally serve two purposes in chalk art: the first is to define space, and the second is to complement a design. Both are important!

A border helps to organize and declutter specific parts of your design that may otherwise appear jumbled. However, a border should never overpower the design itself; its purpose is to enhance the flow of the design. This page shows how borders can positively break up a space that would otherwise appear crowded. The eraser, ruler, sharpener, and this paragraph are all bordered in a way that organizes the entire flow of the page. Without them, the layout would appear cluttered and mismatched.

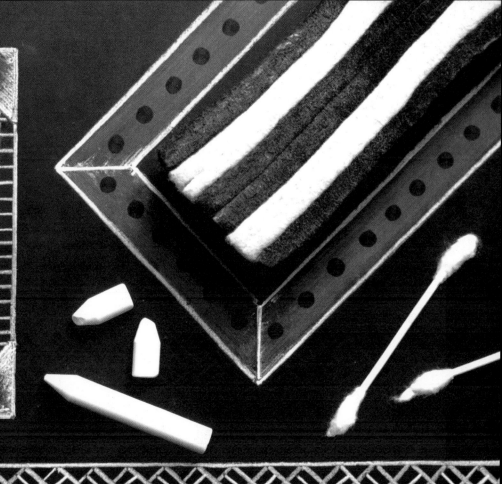

A border can also complement a design, adding charm and appeal. Borders can be as simple as a boxed line surrounding an image, or more intricate, like a repeating pattern.

Borders are generally placed around an entire design, while frames usually appear within a design. Both can work interchangeably, depending on their placement.

In a lettering piece, words and phrases within a frame will stand out more than those placed outside a frame. A design with a border or frame will feel more complete than a design without one.

Design a Border

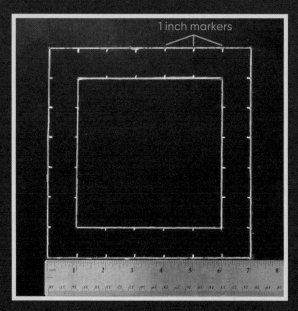

Determine the size of your border using a ruler, then use your ruler to add one-inch markers around the inside of your border. Be sure to add them to the inside of both squares. These will serve as guides when you start adding line details to your border.

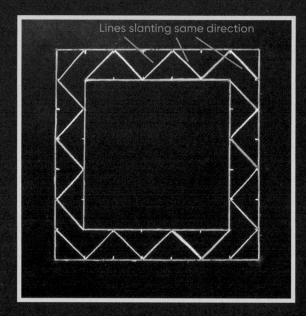

We usually begin by adding all the slanted lines going one direction, and then the slanted lines in the other direction. You can get really creative here! Once your markers are down, the sky's the limit and you can create almost any kind of pattern!

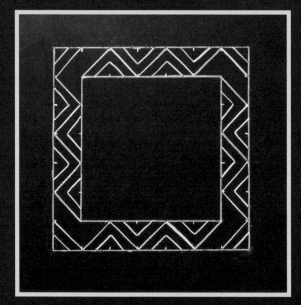

You can always stop at Step 2 if you are happy with how your border looks. Or, you can take it a step further to see what fun patterns will emerge as lines and details are added. Continue to use your markers as necessary.

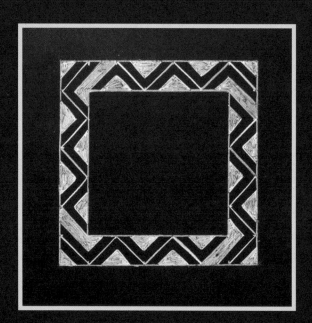

For this particular design, we added chalk highlights to certain areas of the border. This creates a beautiful contrast between the chalk and chalkboard that is eye-catching and fun for all types of chalk art!

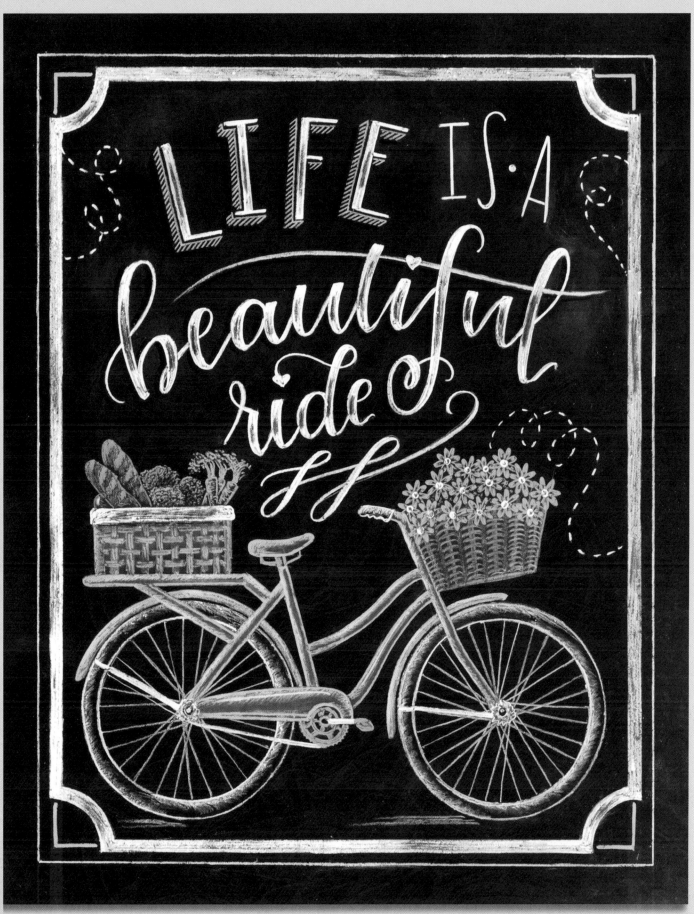

In the bicycle design to the left, the border was drawn before anything else in the design. This way, the interior space could be filled efficiently. For some designs, the border can be added after the interior design has been completed, but for this particular layout, the border helped frame what was going to be placed inside of it prior to beginning the interior. Notice how the border has simple design elements, instead of a specific pattern. The corners complement, rather than detract from the overall aesthetic of the design. As a result, the focal point becomes what is actually found within the border.

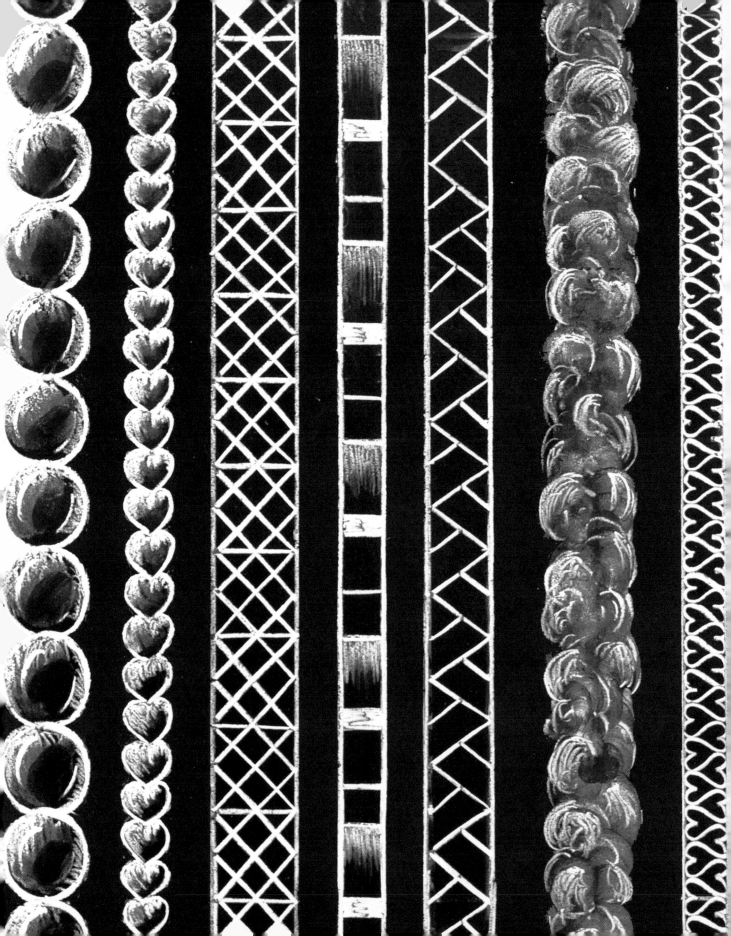

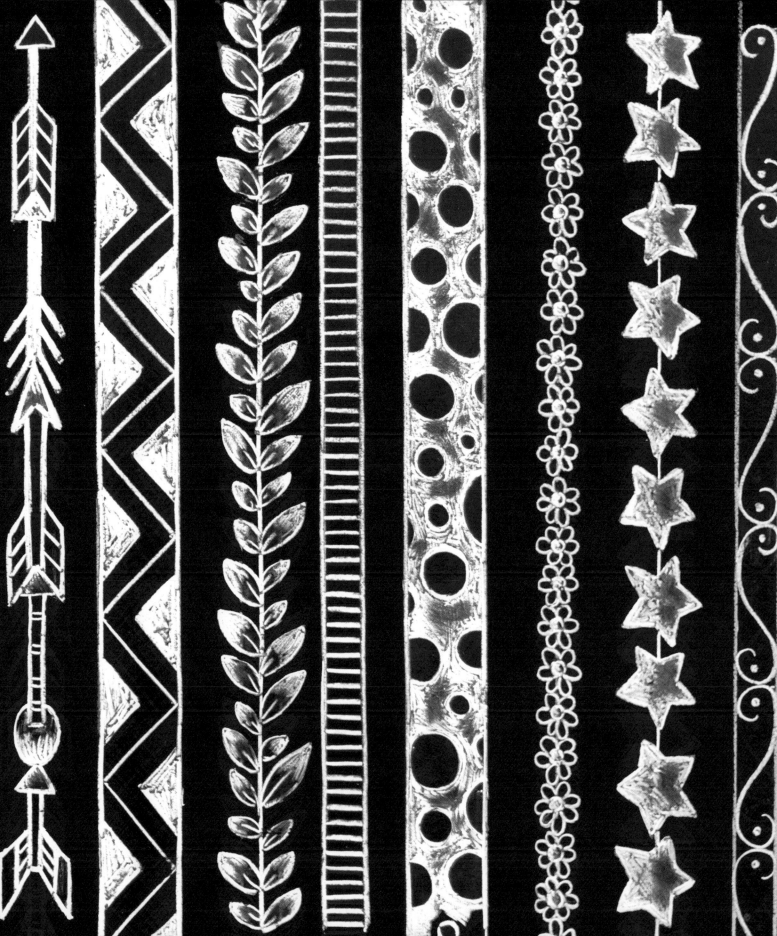

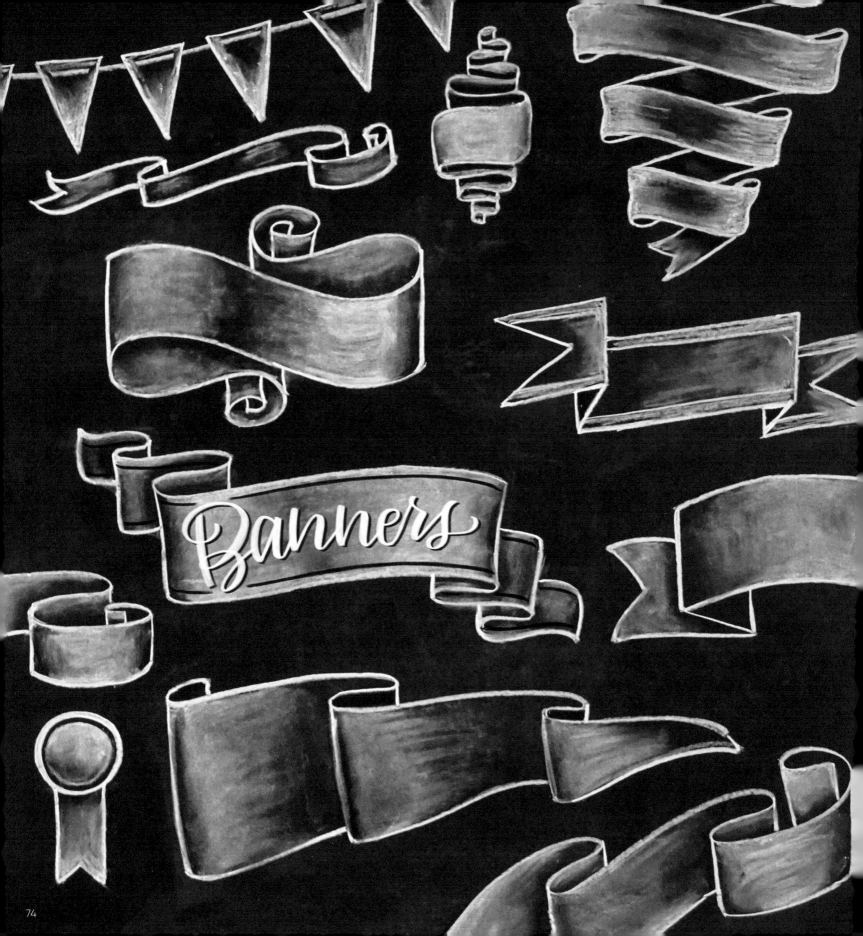

Banners

curved banner

Step 1:
To create a curved banner, first draw a repeating wave.

Step 2:
Draw vertical lines down from all of the points where the ribbons "change direction." These vertical lines should be the same length. Here, you will begin to see the "front" of the ribbon.

Step 3:
Draw horizontal lines that mirror the initial repeating wave line.

Step 4:
Draw vertical lines that sit "behind" the ribbon. These connect to the body of the ribbon, and give the illusion of the ribbon layering on itself. Draw a dot in the middle of the ribbon end; this will be a guide for the ribbon end.

Step 5:
Connect the dot to the ends of the lines, creating a clipped angle ribbon end.

Step 6:
Color in the middle of the ribbon sections, and the very end of the tail. These will be your highlight areas.

Step 7:
With your finger, use small circular motions to softly blend out the chalk, keeping most of the chalk in the middle of the ribbon and less toward the end of the ribbon. Avoid putting chalk in the areas that sit "behind" the ribbon.

Step 8:
Use your eraser to add more dimension: darken up the areas that curve behind. You can also use your eraser to write lettering on your ribbon.

Step 9:
Use a piece of sharpened chalk to write on top of the shadow.

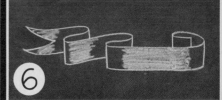

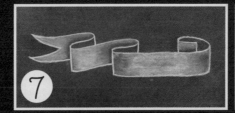

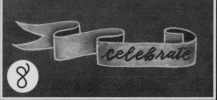

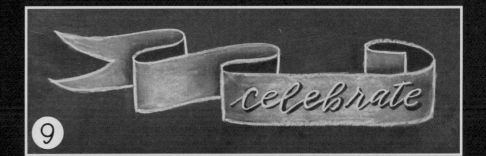

FOLDED BANNER

When you create banners and ribbons, consider using a folded piece of paper or a looped ribbon to visualize the lines, angles, and shadows that you have to render in chalk. This reference item can help to make your chalk drawing look very realistic.

Step 1:
Draw two parallel horizontal lines. Connect them with two vertical lines to create a rectangle.

...

Step 2:
Draw two horizontal lines below and to each of the sides of the rectangle. Add those same lines coming off the rectangle. These should be the same vertical distance apart as the center rectangle.

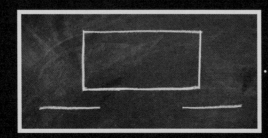

...

Step 3:
Draw dots in the center of each flag end. Connect the corners to the dot in the center. This will create a cut ribbon effect.

Step 4:
Add chalk highlights to the front of the banner.

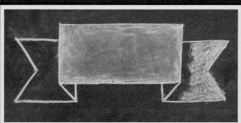

Step 5:
Blend it out with your fingertip.

Step 6:
Add highlights to one end of the ribbon. When you blend, avoid adding chalk color into the area that is close to the fold. This part would have a shadow cast onto it by the center of the ribbon.

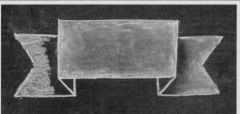
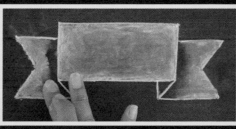

Step 7:
Repeat Step 6 on the other end of the ribbon.

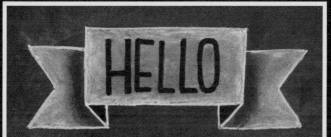

Step 8:
Use your eraser to darken the reverse fold of the banner and cast it deeper into shadow. Write your word on the banner with your eraser to make it stand out from the brightness of the banner.

repeating ribbon

This repeating ribbon is a show stopper!

Step 1:
Draw two parallel stacked S shaped lines equal in length.

Step 2:
Repeat this with shorter stacked waves above and below the center section.

Step 3:
Repeat this yet again. You now have 5 ribbon sections.

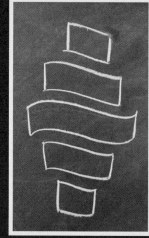

Step 4:
Connect all of these sections with soft vertical lines to close the ribbon fronts.

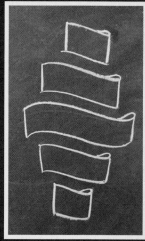

Step 5:
On the top right of each of the ribbons, create a teardrop shape.

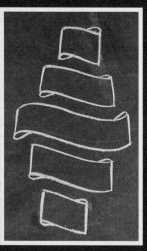

Step 6:
Repeat this teardrop on the bottom left of the ribbon lengths.

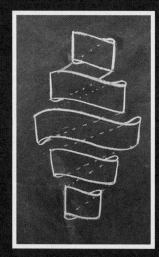

Step 7:
Draw light dotted lines from the top and bottom of one ribbon to the top and bottom

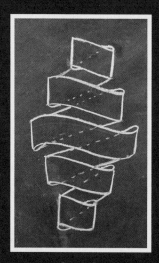

Step 8:
Draw in the sections that would be visible between the ribbon fronts.

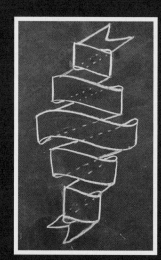

Step 9:
Extend the top and bottom of the ribbon to create your ribbon ends.

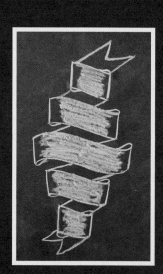

Step 10:
Add chalk to the front centers of each ribbon length. These are your highlights.

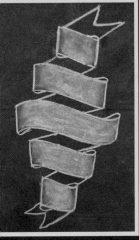

Step 11:
With your finger, blend out the chalk to create midtones.

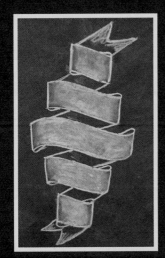

Step 12:
Add chalk to the ribbon ends.

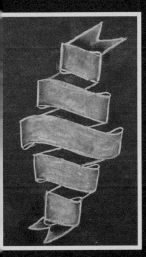

Step 13:
Blend the chalk out with your finger.

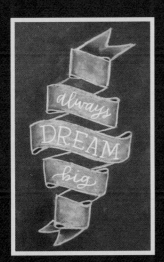

Step 14:
Add lettering with chalk and an eraser to create a shadow.

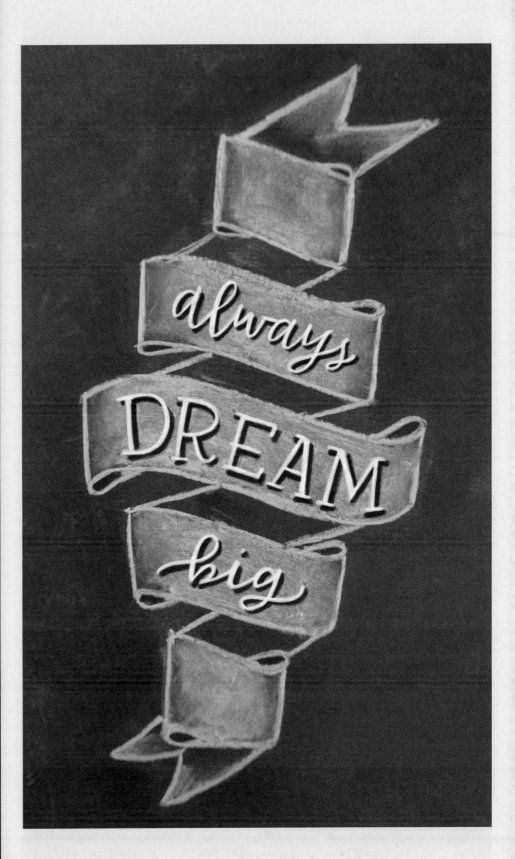

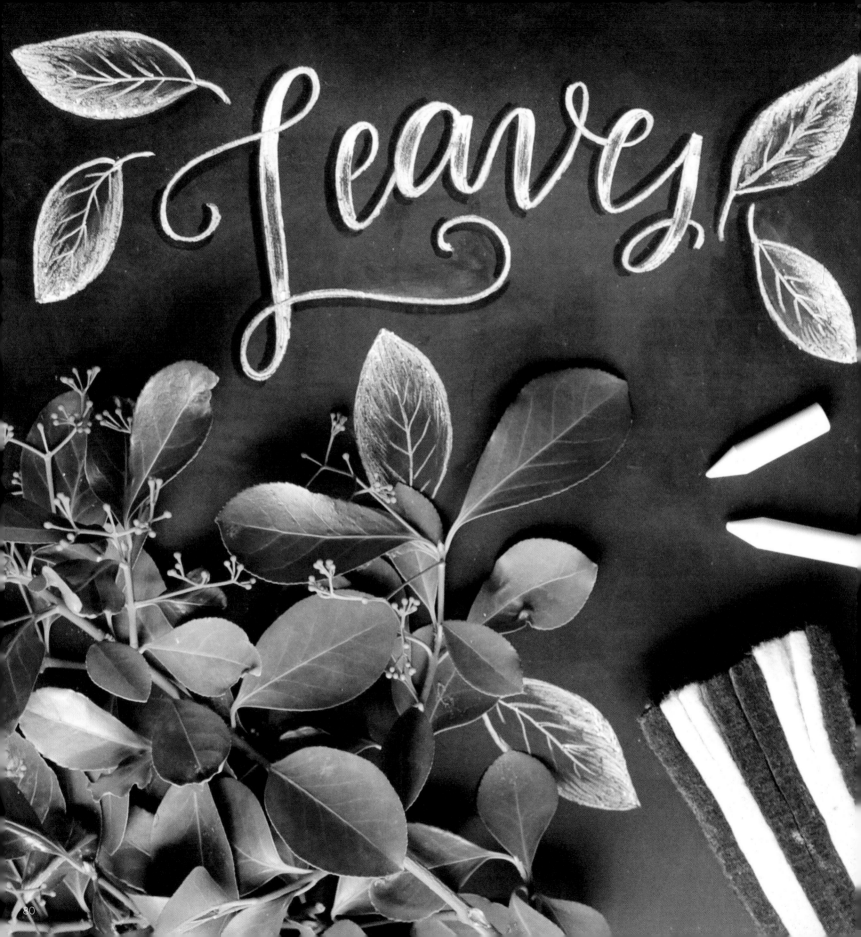

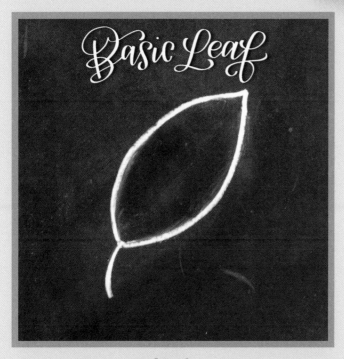

Step 1:
Begin by drawing the shape or outline of your leaf.

Step 2:
Add chalk to the insides of the top and sides of the leaf. This is your highlight color.

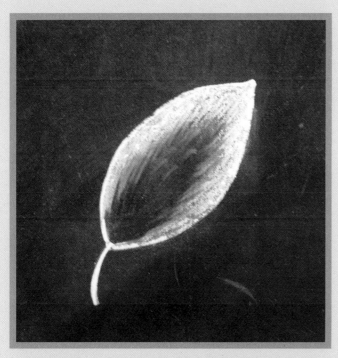

Step 3:
Use your cotton swab or finger to soften and blend the chalk into the chalkboard.

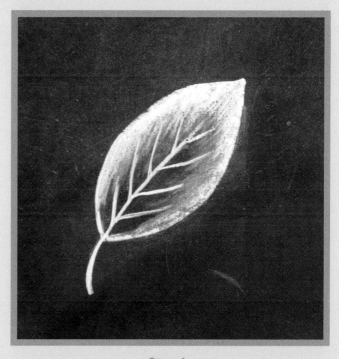

Step 4:
Once you have blended your chalk, you can add leaf lines to complete the leaf.

Step 1: Starting from a single point, draw two symmetric horizontal lines. Then draw a vertical line up from your starting point, and finish with two lines falling at a 45 degree angle in between.

Step 2: Draw the outline of one half of your leaf. Don't worry about perfection here. Every leaf is different, and each leaf part will be different, too.

Step 3: Continue to make the outline of your maple leaf. The original five lines should guide you in placing the leaf outline. Once the outline is done, you can add your highlight.

Step 4: Highlight the outer edges of the leaf with chalk. There will be a strong contrast between the highlight and shadow colors, as no midtone color is present yet.

Step 5: Use a cotton swab to gently blend the chalk into the chalkboard of your leaf outline. You should start noticing some midtone colors as you blend the highlight and shadow.

Step 6: Continue to blend, shade, and highlight your leaf. When you are finished, add the leaf lines and a stem to your leaf. You now have a beautiful chalk maple leaf!

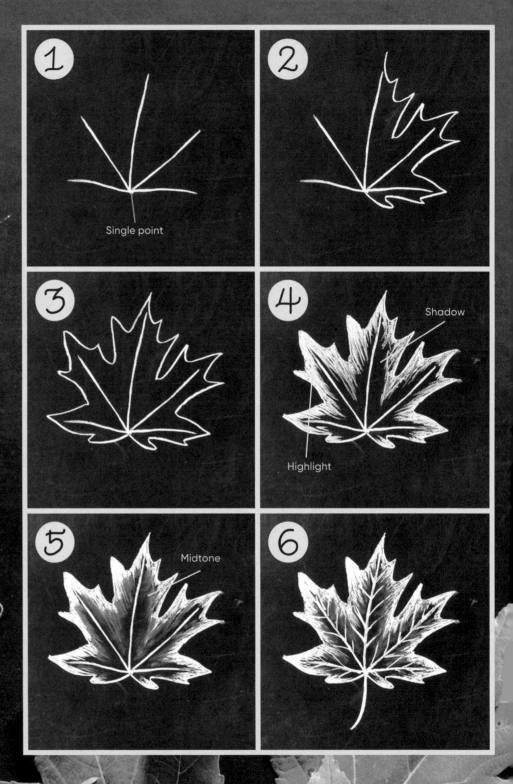

Tropical leaf

To create a tropical leaf, follow these steps:

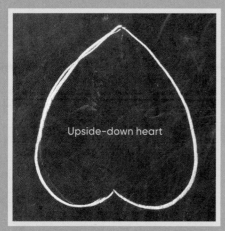

Step 1:
Create an upside-down heart shape.
(It doesn't need to be perfect.)

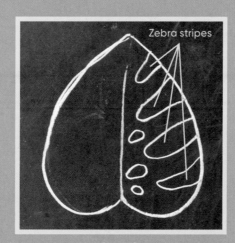

Step 2:
Draw a line up the middle, then begin
adding zebra-like stripes and connect
them to the outer leaf line. Add some
unevenly placed holes toward the
center of your leaf.

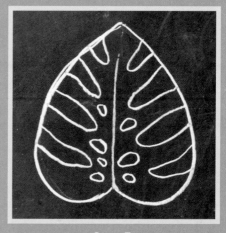

Step 3:
Continue adding stripes and unevenly
placed "holes" on the other side of
your leaf until it is filled.

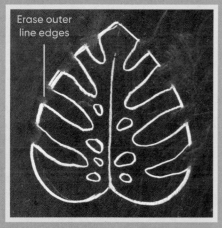

Step 4:
Erase the outer edge of the "stripes"
that you added (in step 2) to form the
final tropical leaf outline.

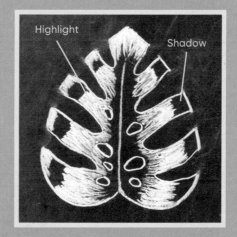

Step 5:
Add chalk highlights to the middle
of each leaf half, and any other area
you want highlighted in your final leaf.
Leave plenty of shadow for blending.

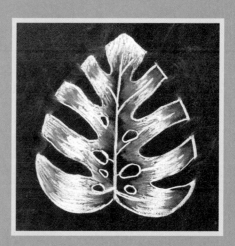

Step 6:
Use a cotton swab and your finger to
gently blend the highlights into the
shadow to create a midtone. Your
colors should blend together, adding
depth and dimension. Add leaf lines,
shadow, midtone, and highlight as
needed to complete your leaf.

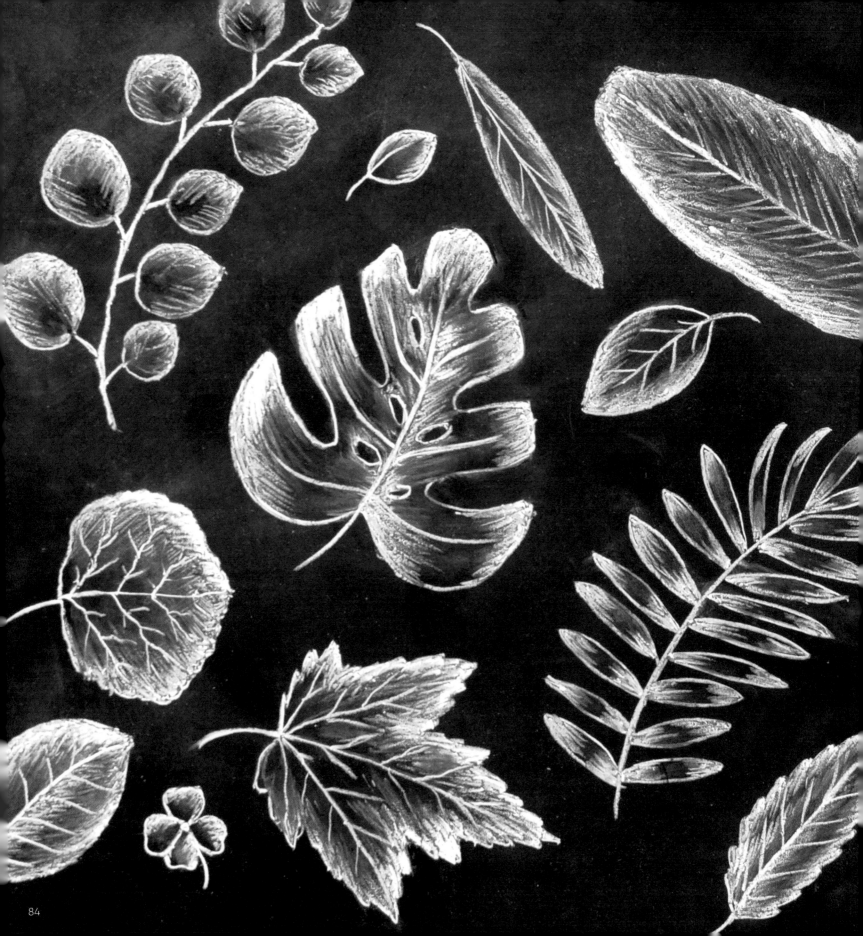

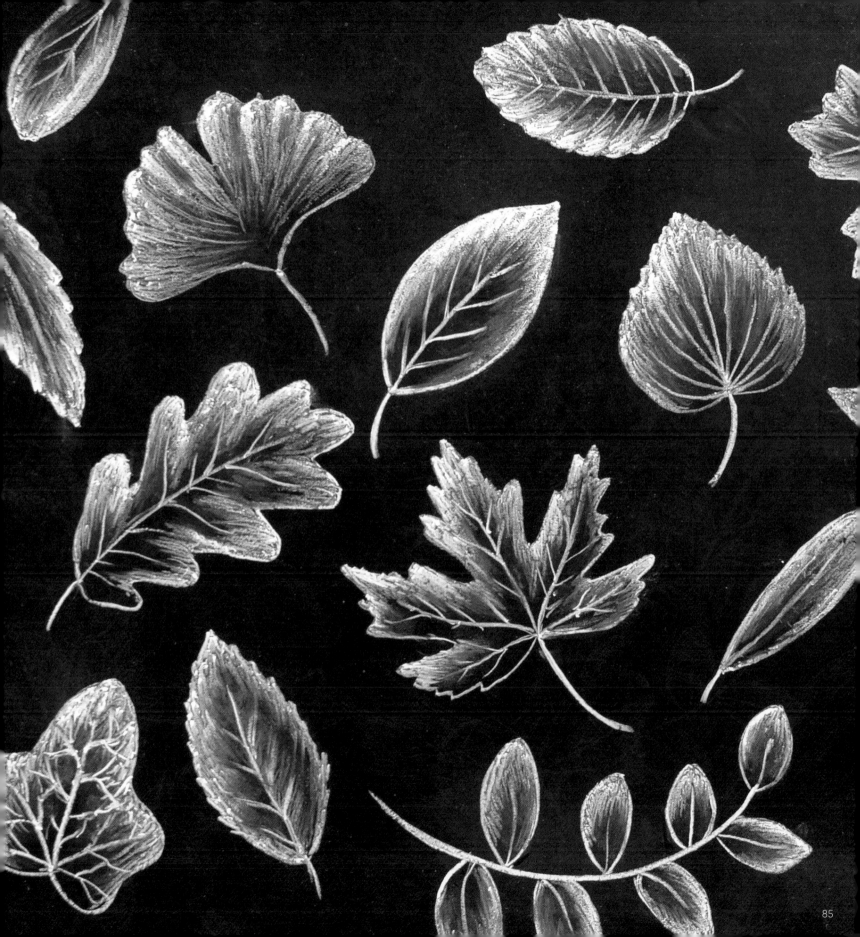

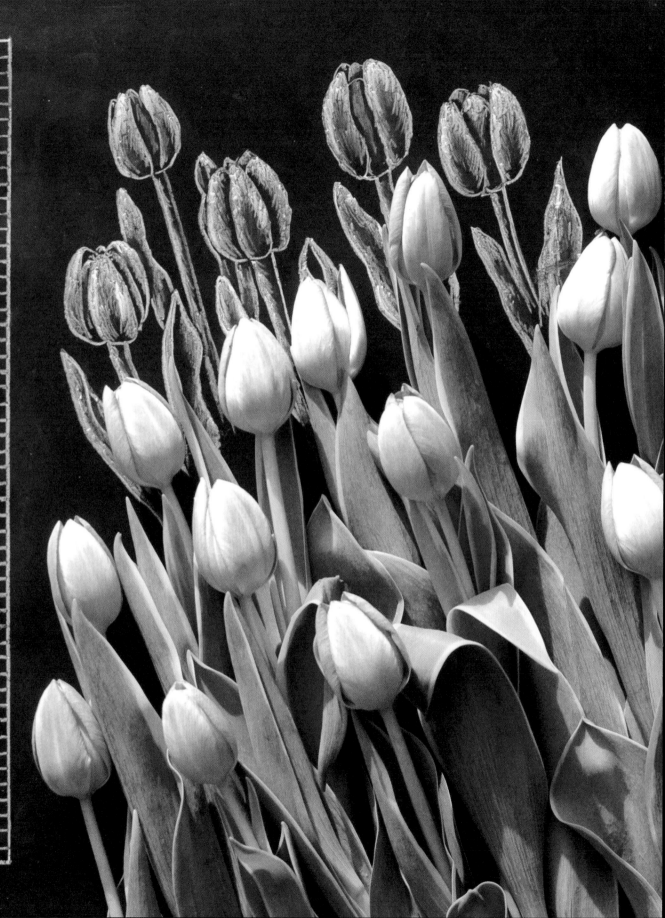

tulip

Step 1:
Begin by drawing the left tulip petal outline.

Step 2:
Add a second petal outline that almost mirrors the first one.

Step 3:
Add the center of the tulip, so that it appears to be behind the first two petals.

Step 4:
Add chalk highlight to the outer edge of the tulip petals, but leave the lower edges alone.

Step 5:
Use a cotton swab or your finger to gently blend the highlight into the chalkboard to create a soft midtone shade.

Step 6:
The tops of the petals should appear more highlighted, while the lower and middle edges should appear more shadowed. Finally, add a stem.

rose

When drawing a rose, we recommend that you start from the center and work your way outward. After the entire rose outline is drawn, go back and add the shading and final details. Each rose step is shown in coral. This serves as a guide as the rose grows and more petals are added. Don't worry if your petals and final rose don't look exactly like the example. No two roses are identical, and there is beauty in variety!

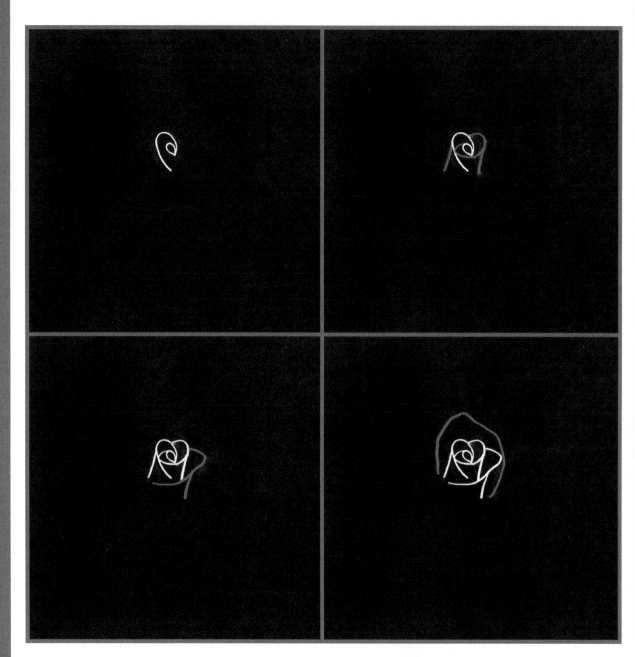

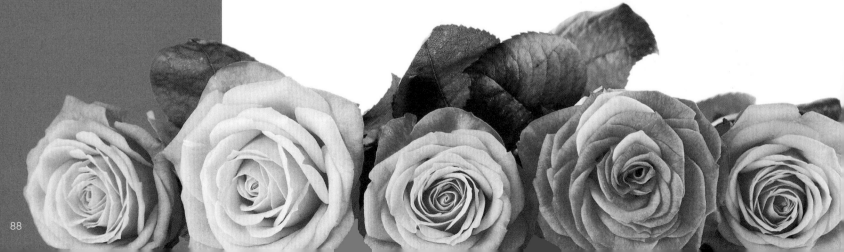

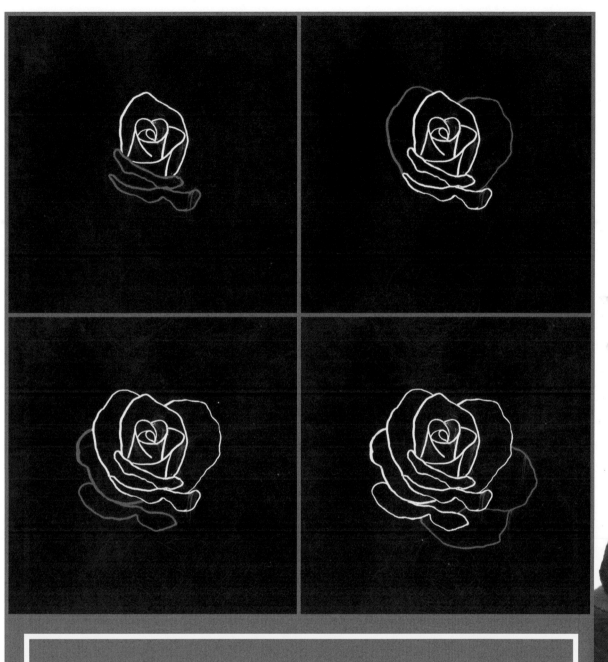

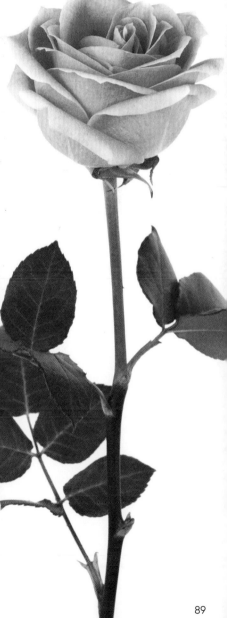

As the rose grows in size, you'll notice how petals are added in a counter-clockwise direction. This can be helpful when adding petals to your roses. The center petals will always appear tighter and closer together when compared to those on the outside, similar to how a rose opens when it is in full bloom.

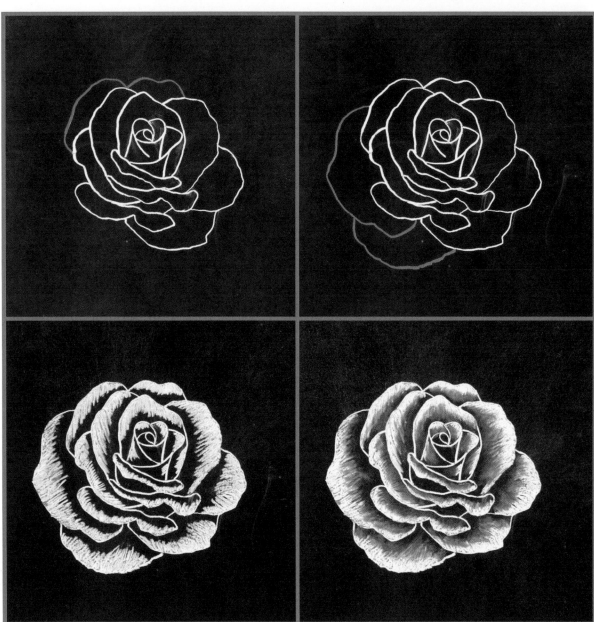

Once all petals have been added to your rose, you have your final outline. Use your chalk to highlight the outer edges of each petal. The inner edges of each petal should appear dark and shadowed. Using your finger and a cotton swab, gently blend the highlight color into the chalkboard shadow. Your rose should look start to look more realistic as you blend.

Continue to blend your rose. If the shadows at the edges of the petals become too light, simply use your pencil eraser to make them darker again, then re-blend. Once you have finished blending your petals, you can go back over the edges with chalk to make select petals even more highlighted. You can add a leaf (or several). To do this, first create your leaf outline. Next, add highlight to the outer edges of the leaf outline, and blend the highlight into the shadow to create the midtones. Finally, go back and lightly add leaf lines to complete the leaf. You now have a beautiful chalk rose!

Sunflower

Step 1:
Begin by drawing a light circle on your chalkboard. Next, draw a second circle inside of the first. These two circles will serve as the inside of your sunflower.

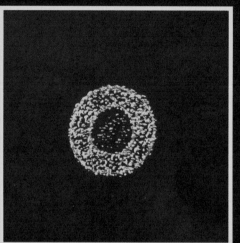

Step 2:
Add dots and small strokes to fill the spaces between the two circles. Press hard with your chalk strokes to highlight the outer circle. Then, add some light strokes to the center of the middle circle (but do not fill it in like the outer circle).

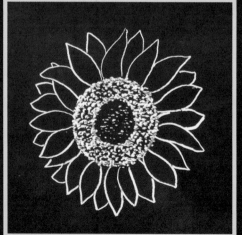

Step 3:
Add petal outlines to the edges of the outer circle. Make them uneven and turn them different directions to give your sunflower a more organic, natural feel.

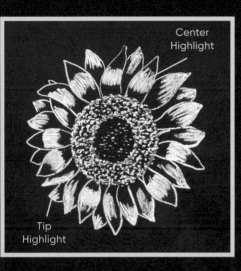

Center Highlight

Tip Highlight

Step 4:
Add chalk highlights to the ends and/or middle of your petals. Highlighting the middle of your petals will give them a curved effect once the chalk is blended.

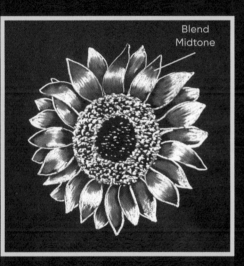

Blend Midtone

Step 5:
Use your finger or a cotton swab to gently blend the chalk into the shadow areas of your petals, being careful to leave the highlight areas brighter.

Leaf Lines

Step 6:
Add final touches of highlights and shadows as needed. Then, go back and lightly add petal lines. This completes your sunflower!

When you combine beautiful lettering and floral illustrations, you are sure to brighten up any space! When you create a bouquet of chalk flowers, be sure to start with one or a few flowers, and then build off of them. Drawing flowers behind and next to the original flower(s) will allow you to create a piece that shows depth and variety. The lettering and illustrations should flow together to create a cohesive, eye-catching piece!

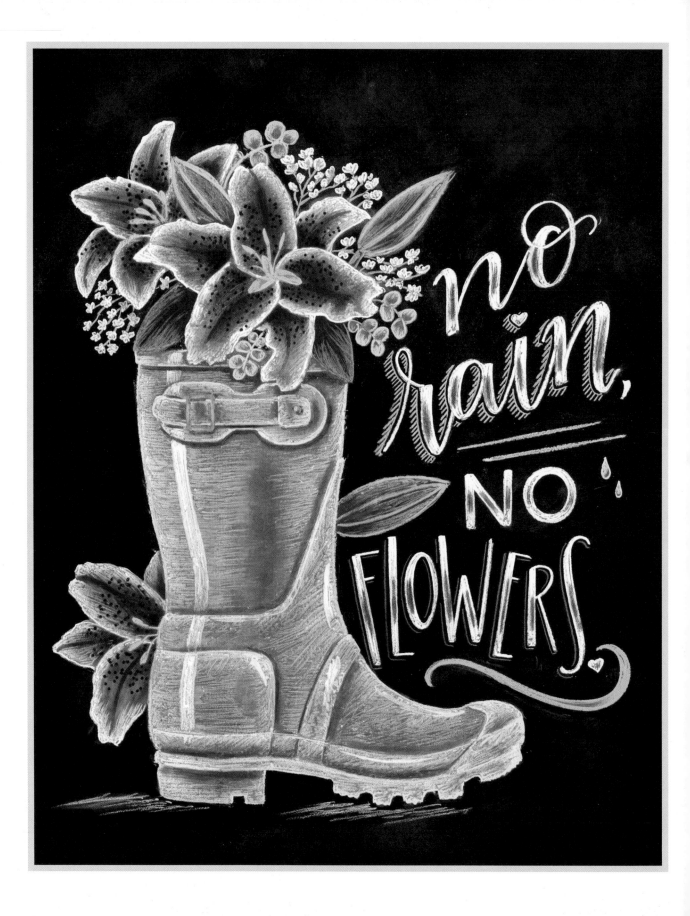

feathers

The addition of feathers to your chalk art provides an uncommon yet soft element that can add a feathery flurry of interest to your piece. Consider adding feathers woven into your piece, as part of a larger design or even as a wreath alternative to frame your lettering.

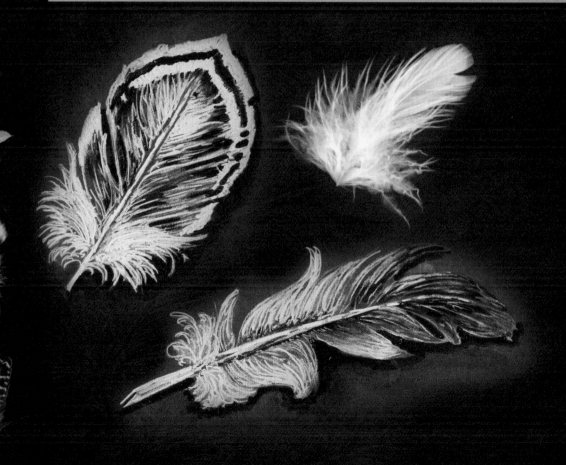

Step 1:
Sketch in a slightly arched tapered double line for the shaft of the feather.

Step 2:
Trace a light outline to show the outer-most edges of your feather.

Step 3:
With a very sharp piece of chalk, begin to fill in the outline with light lines originating from the shaft. These lines will look most natural if they are gently curved and thin like the barbs on a real feather.

Step 4:
Using your finger or a microfiber cloth, gently remove the outer guidelines.

Step 5:
With an eraser, deepen areas of the feather that have dark patterns, shadows, or black tones.

Step 6:
Go over your design to add more areas of detail and light portions of the feather. You can also use a very sharp piece of chalk to draw barbs over top of the darker areas in the feather. This will help to give more depth and interest to the feather.

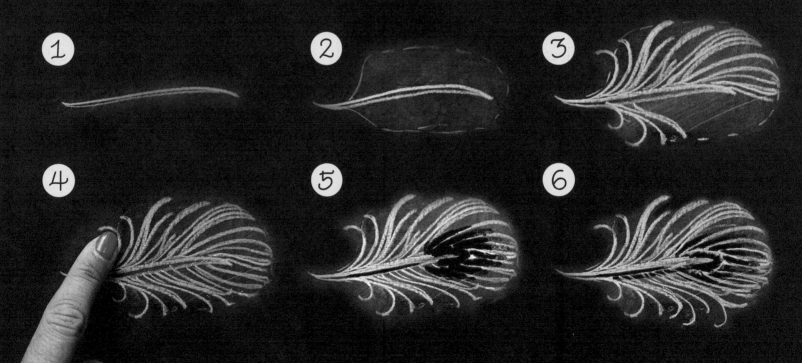

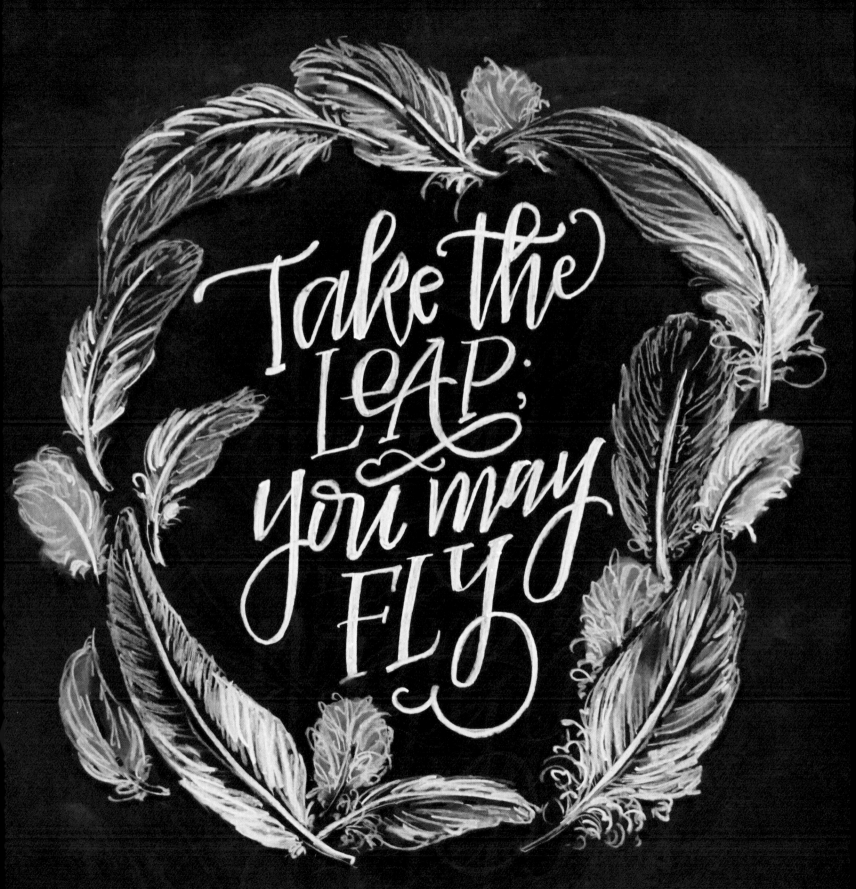

butterfly

Begin by drawing a basic butterfly outline. It's okay if the wings aren't exactly the same! Once you have your outline, add chalk dust to the wings. This creates a midtone gray color that allows you to add shadows and highlights. Once you have chalk dust on the wings, use a pencil eraser to "draw" a pattern of your choice on the wings. The midtone gray color will show in areas that aren't "colored" black with the eraser. (In this particular design, the black is intended to show up as a wing color, rather than as the shadow area of the butterfly.) Once you have added detail to all four wings, use your chalk to add highlight colors to the wings, but don't cover the entire midtone area with highlight. This way, you have contrast between the colors and parts of the wings. Finally, add highlight to the body of the butterfly, and add a head and antennae. This completes the steps to creating a gorgeous chalk butterfly!

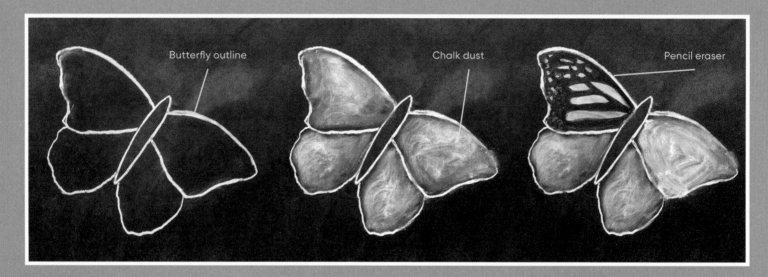

Butterfly outline

Chalk dust

Pencil eraser

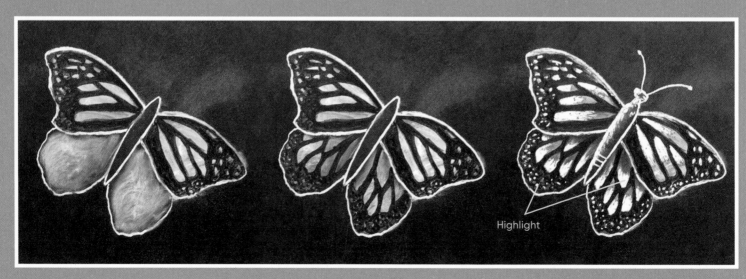

Highlight

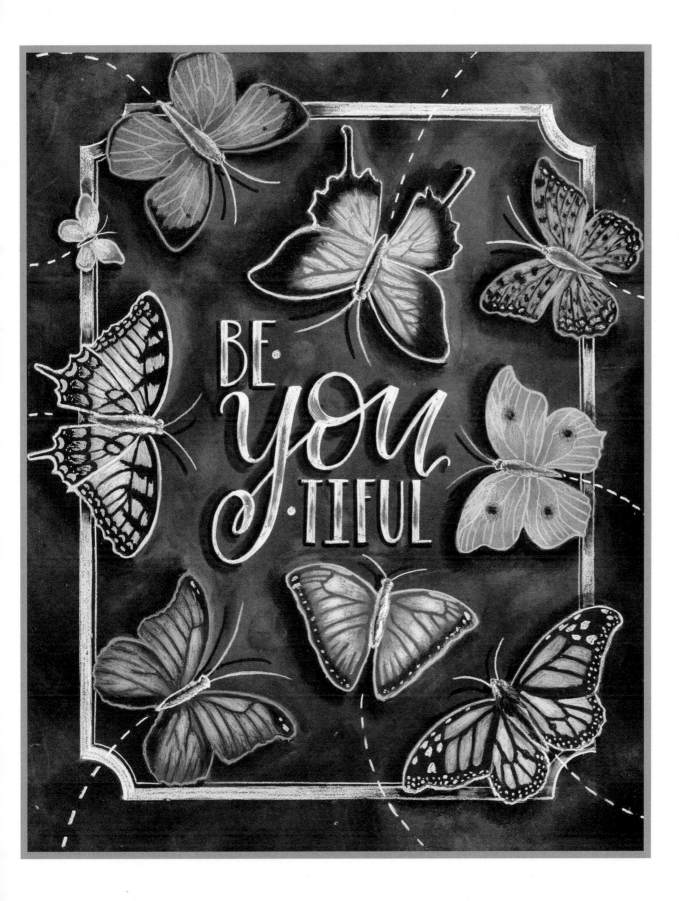

In the butterfly design to the left, chalk dust was added first, followed by the lettering in the center. This way, the butterflies could be drawn around the text without smudging it. Since chalk dust was placed on the board prior to drawing the design, dark shadow elements could be placed next to each butterfly, giving the illusion that they are flying over the chalkboard.

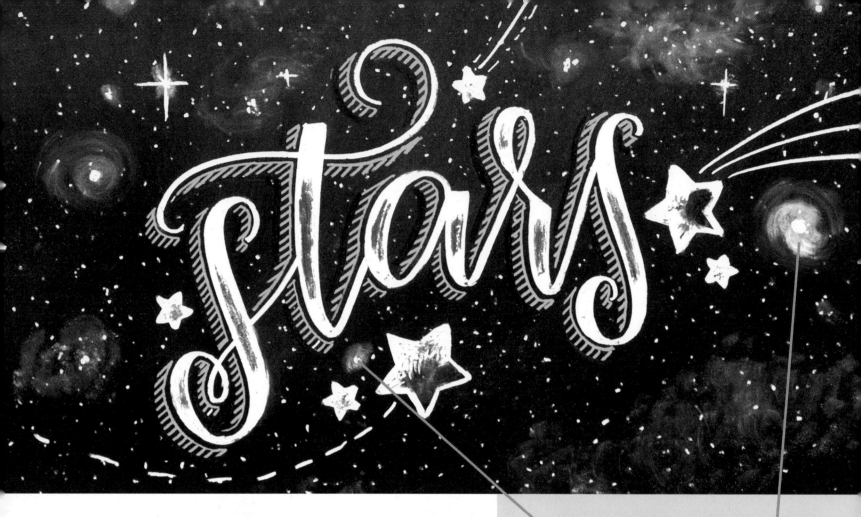

The naturally black background of the chalkboard can be used to your advantage whenever you are drawing a space design or adding stars to your chalkboard art. Using chalk dust will help you to achieve a more realistic space and star appearance.

Simple stars can be created by adding dots all over your board. To make them glow, however, you will need chalk dust. To create a dusty space scene for your stars, you simply need to use your felt eraser to "erase" and spread chalk dust. In the starry image above, the felt eraser was used to create those glowing areas.

Adding traditional star shapes to your designs will add an additional dimension. To create shooting stars, simply extend curved lines from the star to the desired areas of your board. These lines can be filled, dashed, or even smeared to create a shooting star effect.

To add glow to chalk stars, follow these steps:

Step 1:
Begin by drawing a dot with your chalk. The thicker the dot, the bigger the smear will be.

Step 2:
Use a felt eraser to swirl the dot around to smear the chalk. The outer edges of the smear should appear faded compared to the inside.

Step 3:
Once the original dot has been smeared through, add another dot to the center of the smeared chalk. This makes the center dot appear to glow, similar to how stars in space glow.

I Love you past the Moon

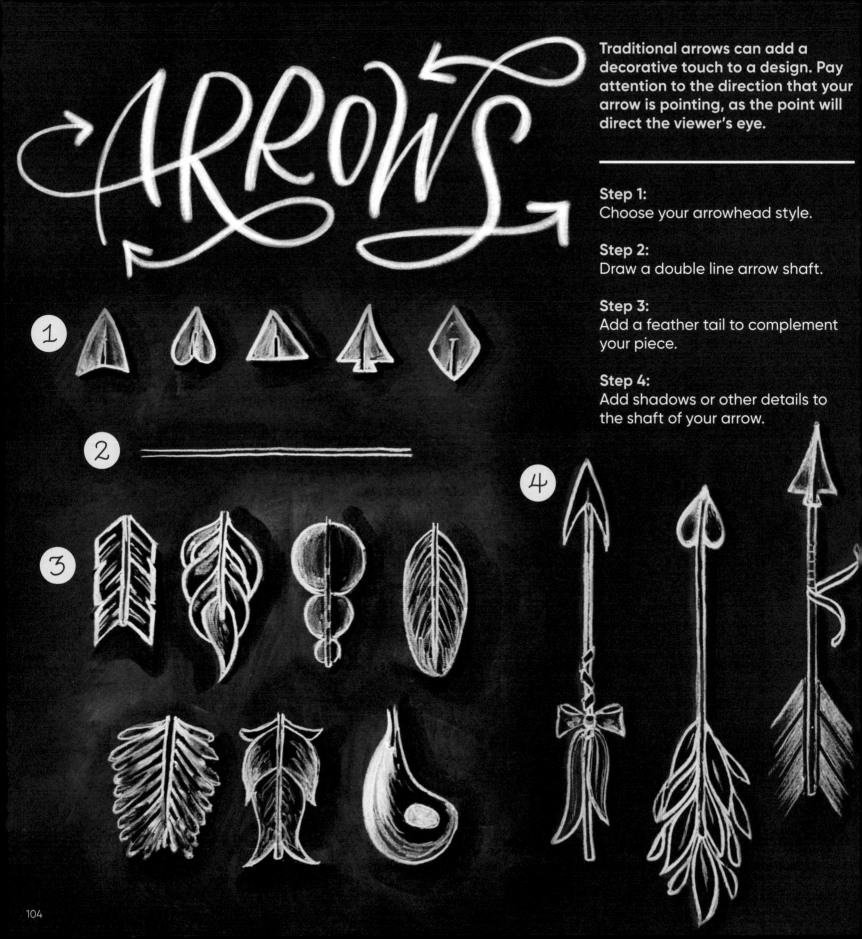

ARROWS

Traditional arrows can add a decorative touch to a design. Pay attention to the direction that your arrow is pointing, as the point will direct the viewer's eye.

Step 1:
Choose your arrowhead style.

Step 2:
Draw a double line arrow shaft.

Step 3:
Add a feather tail to complement your piece.

Step 4:
Add shadows or other details to the shaft of your arrow.

Less traditional and more geometric arrows are also a great way to direct the eye, fill space, and enhance your design. You can even consider placing lettering inside the arrows!

Design

How do you know which words should stand out? In the example of "yes you can" on the next page, shifting the focal word changes it from being a statement of positivity (YES you can), to a statement of entitlement (yes YOU can), to a statement of empowerment (yes you CAN).

When you create a piece, ask yourself which words are the most important ones, and select them to emphasize.

Remember, the lovely thing about chalk is that if you don't like something you have created, you can simply wipe your chalkboard clean and start again. Don't be afraid to experiment: try new combinations of words and styles, and have fun as you learn!

✔ **Correct Grammar**

✔ **Punctuation**

✔ **Reading Left to Right**

✔ **Legibility**

Pick YOUR STYLE

Sometimes it is easy to pick what you want to write, but more difficult to decide how to write it. Which lettering style do you choose? How should you place your words? What do you need to focus on? Don't fret! Just keep these keys in mind: style, size, strength, and importance.

Style
You can choose a dramatic style for specific words to make them "pop." In this example, the word "yes" is emphasized by its unique style.

YES YOU CAN

Size
Here, "you" stands out because of the larger font size used.

Strength
To add focus to a particular word, try increasing the "weight" of the letters (while keeping a consistent style and size). As you become more comfortable with various design options, try mixing and matching sizes, styles, and strengths in interesting combinations!

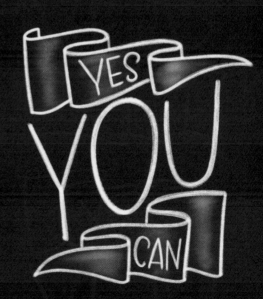

NEGATIVE SPACE

In simple terms, negative space refers to the areas surrounding the main objects in an image. In chalkboard art, negative space refers to the black chalkboard background. Since chalk is the tool used to write on a chalkboard, the whiter colors of the gray-scale often become the main focus of a design. This is also known as positive space. When used creatively,

negative space can add intrigue to your work. In the images below, the main objects are a carrot, a cow, and a heart. All three images would stand alone just fine, but the use of negative space to add lettering creates a more visually stimulating composition. Have fun and get creative!

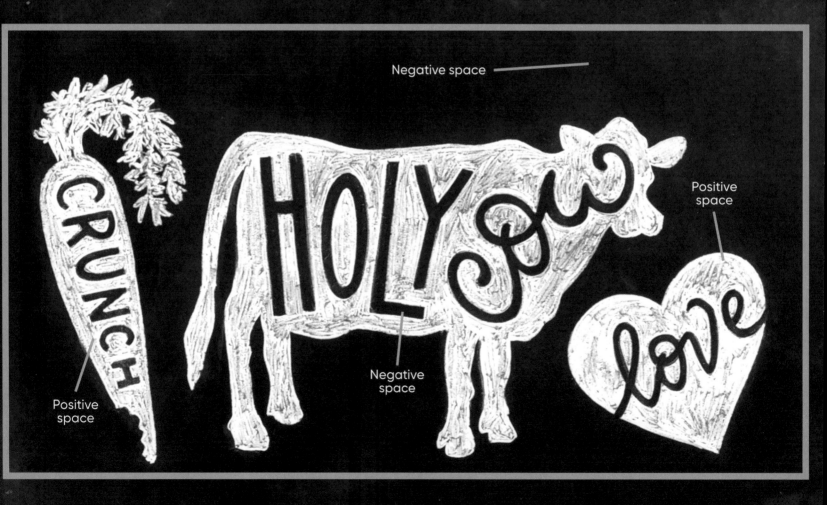

Negative space

CRUNCH

HOLY cow

Positive space

Negative space

love

Positive space

Another way to use negative space in chalkboard designs is through chalk dust. As stated earlier, chalk dust creates an opaque-gray midtone color on your board. This can be used to your advantage in chalkboard designs where you want to use negative space. The dark chalkboard background will come through the gray midtone colors to create a dimensional piece. In the image below, the negative space gives the dandelion the illusion of a silhouette. All three color values of the chalkboard grayscale are present. The midtone acts as the base color in the design, while the shadow color of the dandelion and highlight colors of the words help to create overall balance. To make the dandelion from negative space, chalk dust was added first. Then, the pencil eraser was used to "draw" the dandelion and the seeds. Finally, the lettering was added. As you can see, the word "Happens" has shadow elements next to it, making it pop compared to the other words.

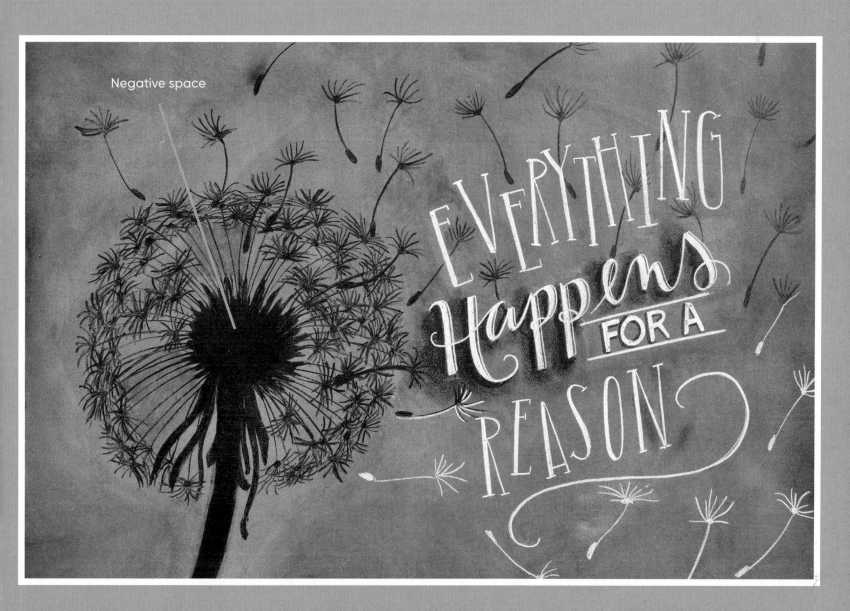

Negative space

EVERYTHING Happens FOR A REASON

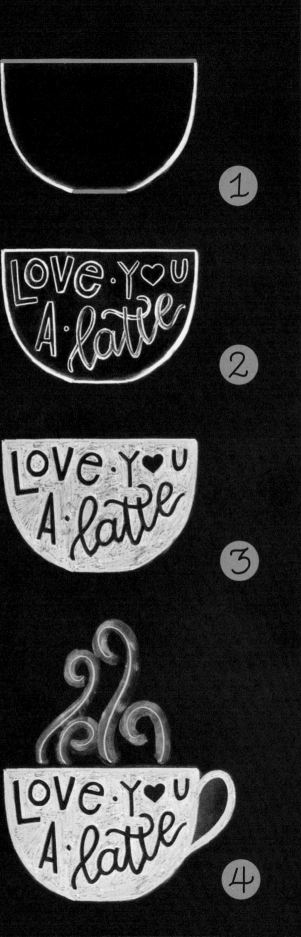

Create a negative space coffee design by following the steps below:

Step 1:
Draw a coffee mug outline. Start with the straight horizontal line at the top of the mug, followed by the smaller horizontal line at the bottom of the mug. Connect the two horizontal lines with curved lines on either side. This will give you the basic outline of a mug.

Step 2:
Write the outline of the words within your mug. This does not have to be perfect. You will perfect the final design once the chalk is filled in everywhere else.

Step 3:
Using chalk, fill in every space around the outlined letters within the mug. We recommend doing this with straight strokes, rather than coloring back and forth with the chalk.

Step 4:
Perfect the lettering by going back over it with a pencil eraser to get crisp lines. If you erase too much, go over those areas with chalk. If too much chalk goes into your lettering, go back over it with your eraser. When you have perfected your lettering, add the mug handle and steam at the top of the mug. To add steam, simply draw a swirled line, then trace over it with your felt eraser. Draw a final chalk line back over the smeared steam to create dimension.

be A MeRMAiD im a SeA -OF- FiSH

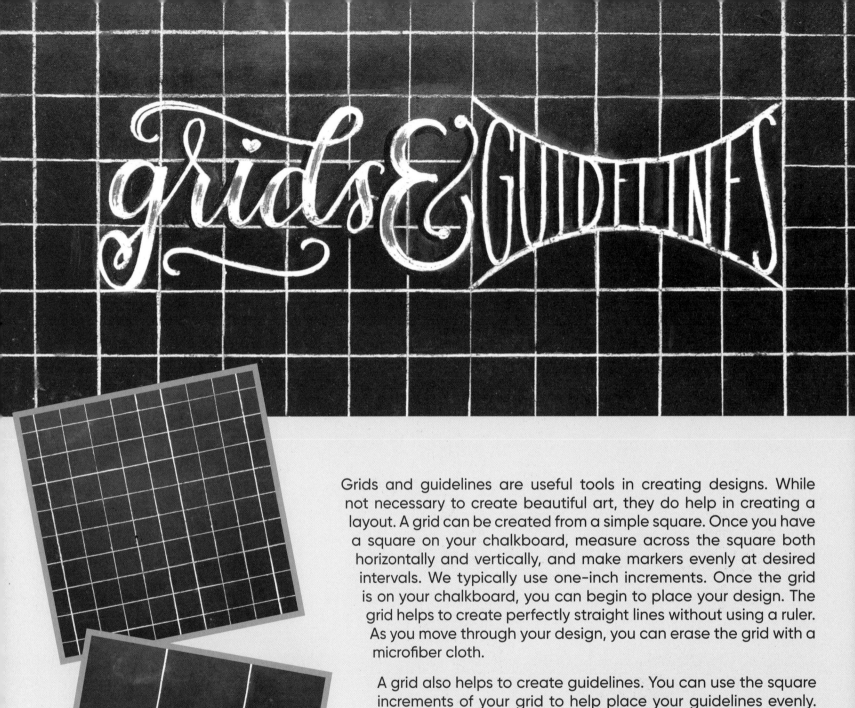

grids & GUIDELINES

Grids and guidelines are useful tools in creating designs. While not necessary to create beautiful art, they do help in creating a layout. A grid can be created from a simple square. Once you have a square on your chalkboard, measure across the square both horizontally and vertically, and make markers evenly at desired intervals. We typically use one-inch increments. Once the grid is on your chalkboard, you can begin to place your design. The grid helps to create perfectly straight lines without using a ruler. As you move through your design, you can erase the grid with a microfiber cloth.

A grid also helps to create guidelines. You can use the square increments of your grid to help place your guidelines evenly. Once a set of guidelines is placed on your grid, you can erase the grid marks within the guidelines. That way, you can have guidelines, but no competing grid marks. In the title above, notice the way the word "Guidelines" is placed within the guidelines of the grid, but no grid marks are within the space behind the lettering. This is why erasing lines as you design can be helpful!

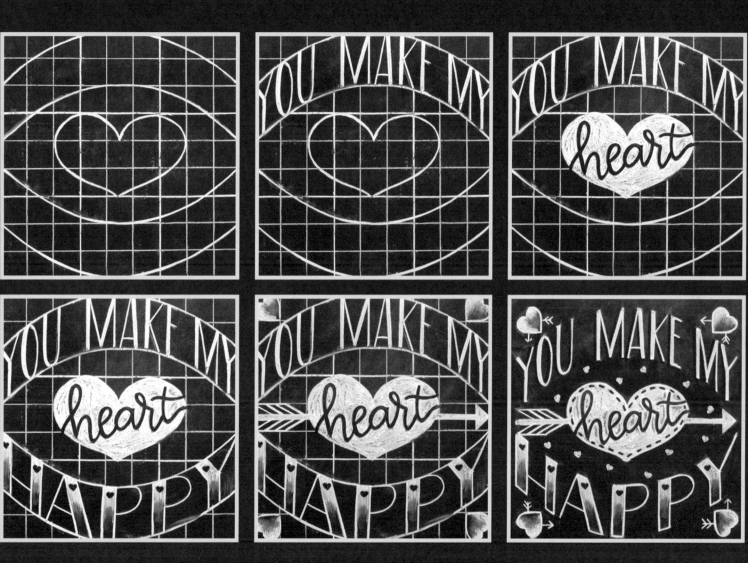

In the sample design above, the grid was created with one-inch increments. After the grid was complete, the guidelines were added. Notice how the grid makes it simple for the guidelines to be placed evenly across the entire design. Whenever we begin a new chalkboard design, we generally work from top to bottom, or center out. For this particular design, we began by working in the grid at the top of the design. Once the guidelines were placed, we erased every visible part of the grid that fell within the guidelines before adding the lettering. This made it easier to see what we were writing, and eliminated the problem of needing to go back to erase grid lines after the final lettering was down.

As you can see above, once the guidelines were filled from top to bottom with lettering, we then went back and added design elements (the arrow and four surrounding hearts) to complement the overall design. To finish the image, a microfiber towel was used to carefully erase the remaining grid lines. For small areas that were hard to erase with a microfiber towel, we used a pencil eraser. To finish the design, we added small floating chalk hearts around the main heart, and used a pencil eraser to outline the heart with dashed lines. As you can see, grids and guidelines can greatly help the design process in chalkboard art.

The images below show several ways that guidelines can shape your letters. If you are using a grid, draw your guidelines and erase between them before you begin lettering. If you are not using a grid, you can still measure from the side of your chalkboard to make sure your guidelines are straight and evenly shaped. You can leave the guidelines in any design, or simply erase the lines after your lettering is complete. Another option is to create a pair of guidelines, but keep the lettering from touching the top and bottom lines. This "frames" the lettering in a unique way.

The coffee design on the next page may appear difficult to draw, but it all began from these simple guidelines. The outer square lines were drawn first, followed by the center dot. From the center dot, both circles were drawn, followed by the horizontal midlines. This is why guidelines are so helpful! They help to shape an entire design before it even starts!

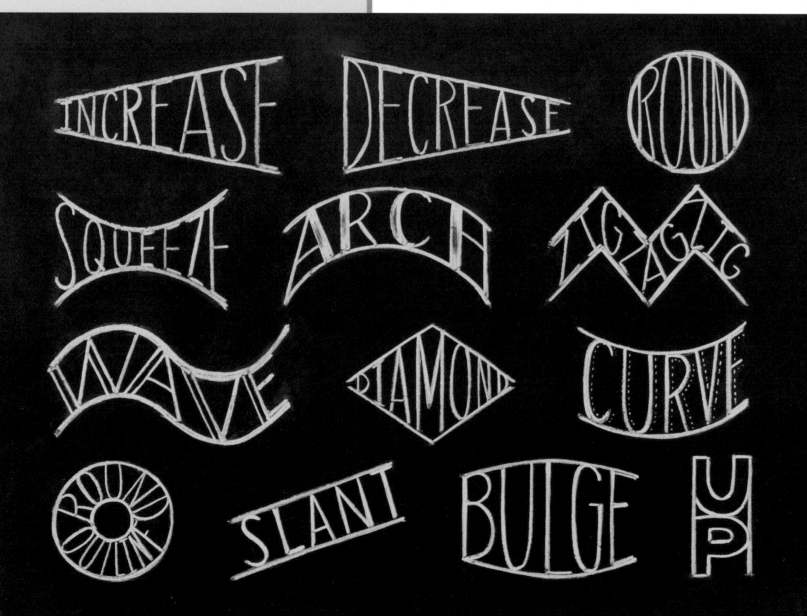

FIRST · I · DRINK COFFEE THEN · I · DO · THINGS

Flourish Time

Flourishes are a fantastic way to add a decorative element, to fill space, or make otherwise simple lettering look amazing. Flourishes are based on overlapping oval shapes that curve from one to the next.

The first flourish that you should master is the parallel oval flourish. The curves and redirections of this flourish can serve as the basis for other flourishes.

Your basic flourish

Step 1:
Draw a curving wave or S-shape where one end starts down and the other end curves up.

Step 2:
Add a second shape that is a mirror image of the first. This one should be slightly lower and slightly smaller than the first curve.

Step 3:
Draw an S-shape similar to the first. Again, it should be slightly smaller. (These curves should all be decreasing in size from the first to the last.)

Step 4:
End the flourish off with a curve that loops over and ends in a "C" shape. Be sure that even the very end of the line has a curve. There should not be straight lines at the ends of any flourishes that you create.

Step 1:
A typical letter "t" has a straight cross stroke like the "t" on the top left. To add a flourish, replace that conventional, straight cross stroke with a curved, oval based line. Select the flourish that will best fill the space without crowding the letters around it.

Step 2:
Once you have selected your flourish and ensured that all areas of it follow the curve (no areas are straight), thicken up your downstroke to increase the strength of the letter. (Don't thicken the flourish; this can potentially decrease the legibility of your piece.)

Step 3:
Finally, add interior details like shadowing, shine, or ombré effects to your letter body on the downstroke. These details should be implemented consistently across the entire word.

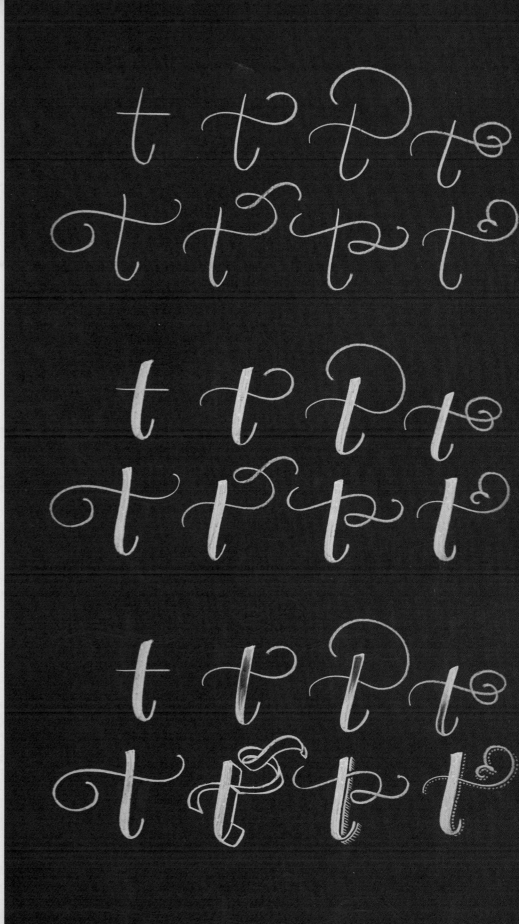

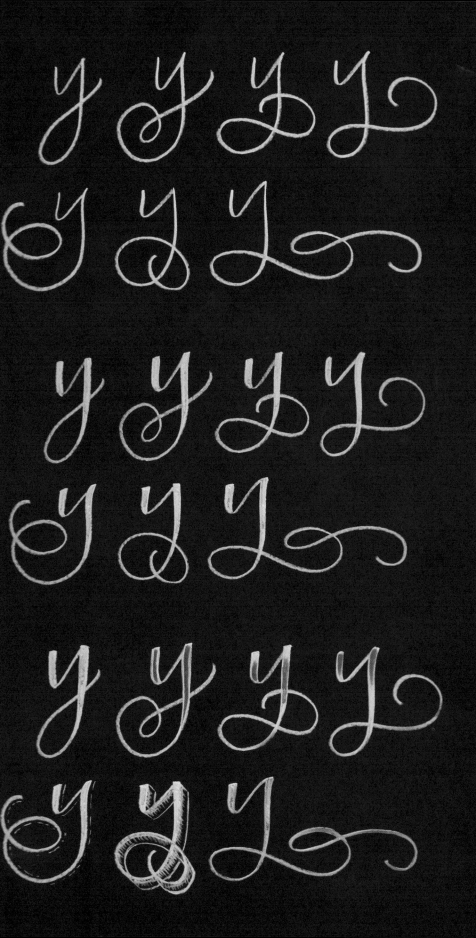

Step 1:
Descenders, also known as the tails of your letters, are perfect opportunities to add a flourish! Where you would typically draw a normal tail, (like the "y" in the top left), add a flourish instead. When you create a word, it may be easiest to draw in a normal tail, and then erase it and replace it with your chosen flourish.

Step 2:
Thicken your downstroke, gently transitioning into a thin stroke before the flourish begins. This allows the flourish to be an embellishment, but doesn't draw the eye away from the letters and words of the piece.

Step 3:
Once your letters are set, add interior details to give your letters that special something.

While flourishing off letters is a natural way to add a fancy element to your work, adding a few flourishes is also a fabulous way to fill blank areas in a piece. When you draw in your flourishes, just make sure that the beginning and the end of the flourishes always have a curve to them (and aren't a straight line). Use this flourish gallery (below) to find the perfect flourish for your space!

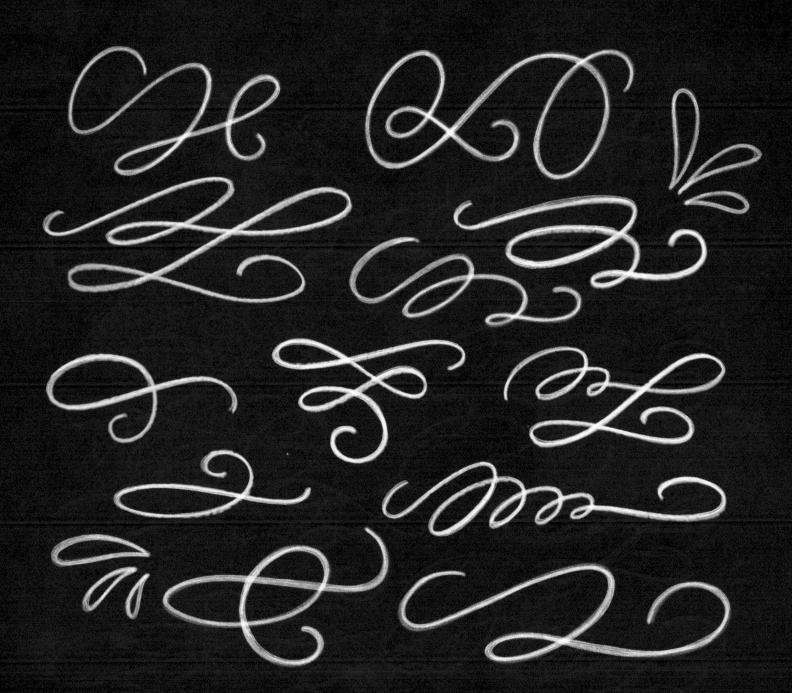

Step 1:
Draw a basic sans serif or script letter.

Step 2:
Consider your letter. Is there space for a flourish at the top of the letter? If so, add one!

Step 3:
If there is space at the bottom of the letter, add a flourish below.

Step 4:
Thicken the downstroke of your letter. (Do not thicken the flourish.)

Step 5:
Use a pencil eraser to add a shadow behind the letter.

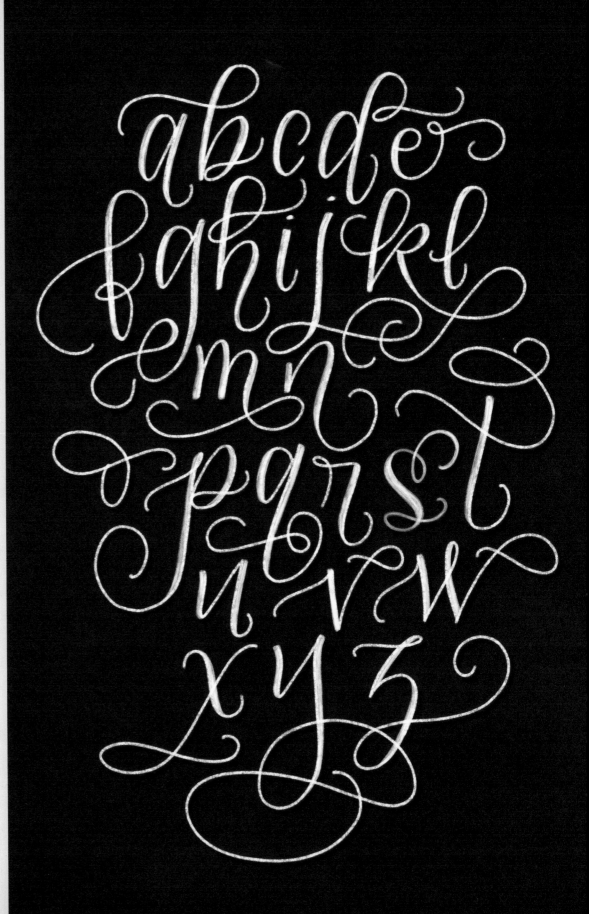

Flourish Placement

Laying out a piece with gorgeously balanced flourishing is so much easier with these simple tricks!

When you stack words, watch for areas where the descenders (the "tails" of the letters) and the ascenders (the parts above the midline) might collide. If that happens, try shifting one of the words to the left or to the right so the letters fit together like puzzle pieces.

Once your words are placed with the ascenders and descenders fitting together, erase the cross strokes and descenders. Doing so shows the obvious areas for cross stroke and descender flourishing. Choose a variety of flourishes to fill those spaces, and then thicken the downstrokes on your letters. (Don't thicken the flourish lines.)

After flourishing off your letters, you can fill the space around the piece with other flourishes and embellishments. For this piece, a circle shape works well. These added flourishes help to create an exterior shape.

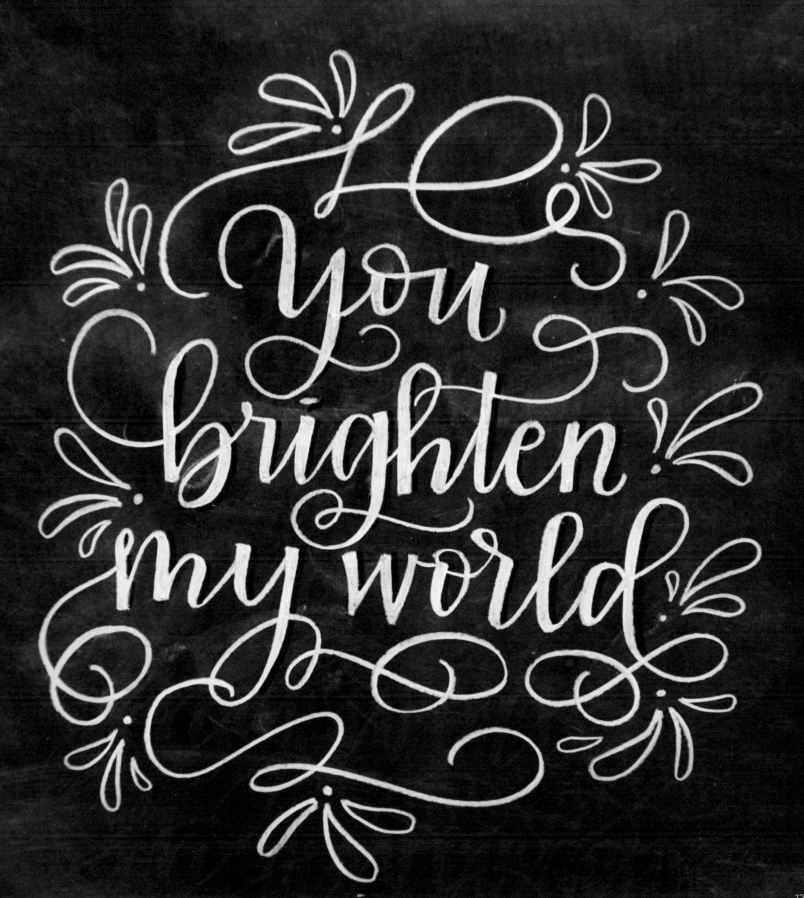

Projects

LOVE builds UP

Imagine that your lettering is made of a ribbon. In order to understand the areas that overlap and those that are the brightest, or alternately, those that are cast in shadow, try using an actual ribbon to understand exactly how to build each letter.

When you create these dimensional letters with chalk, the areas that overlap should be a solid line, and the areas that go underneath should be left blank. First, draw your letter with the skipped background areas. Next, widen your line with the parallel downstroke area. When you color in the letter, don't color in what is near the skipped background lines. Very carefully, feather in light chalk lines to create a soft gradient effect. Keep the areas right beside the overlaps completely black. If these are accidentally colored, erase those spaces with your pencil eraser.

Erase any extra letter portions.

Lightly sketch in your next letter.

Be aware of overlapping ribbons; use more saturated chalk on the ribbon sections that sit in front.

Use your eraser to create shadows behind the letters.

The playful double line letter can be created by drawing parallel lines for each of your regular letter strokes.

Connect those parallel lines with the letter's end lines.

Continue this same double line and close pattern for the other letters in your piece.

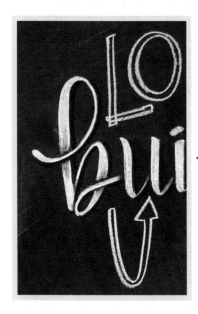 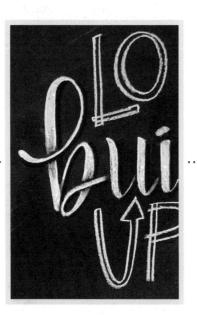 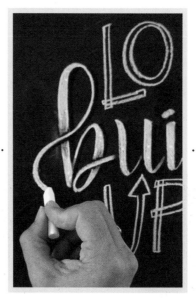 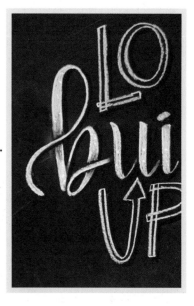

This style also lends itself well to playful additions such as the arrow in the first letter of "up." Sketch those little details in whenever possible!

As you consider your piece, you may notice that a line or flourish should be moved to establish better balance. To do this, very carefully erase the first line with your microfiber cloth before replacing it.

Add shadows to the rest of your letters. The details in and amongst your letters make this piece strong enough to stand alone without illustrations!

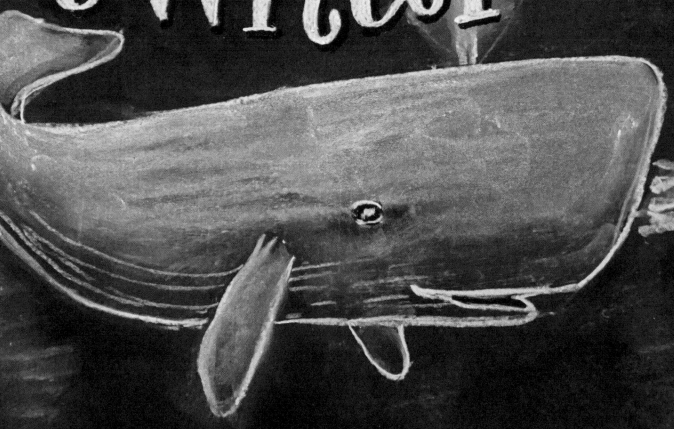

YOU'RE S'WHALE

Let them know just how much you care with this whale and his encouraging message!

1

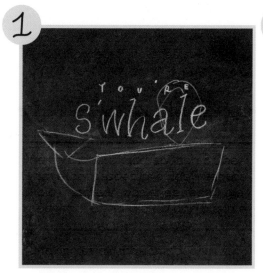

Sketch the rough outline of your design. When you draw, try to piece together shapes as guidelines for your images. A whale is a rectangle body with a triangle tail and a curve to connect the two.

2

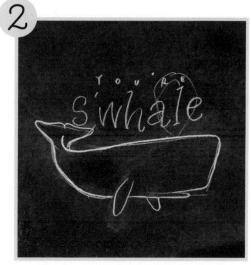

Create the outline for your whale body and add elements such as a mouth and fins.

3

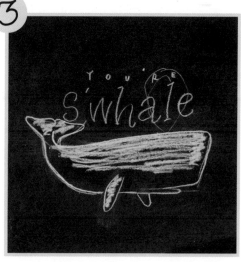

The "light" comes from above the whale. Using chalk, add highlights to the top of the body.

4

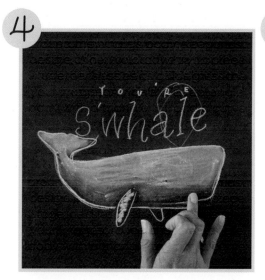

Making small circular motions with your finger, smudge the chalk around the whale's body. Keep most of the chalk toward the top of the whale, and less below. This gives the appearance of depth.

5

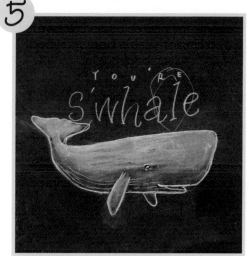

Erase a spot for the eye and then add details such as eyelid and an eye. You can also add fine lines along the whale's stomach.

6

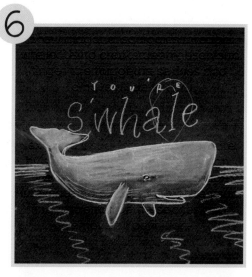

Next, add visual interest to the water by showing "light" cutting through. Draw diagonal squiggles through the water to create depth. Use your finger to smudge these lines and remove all definition.

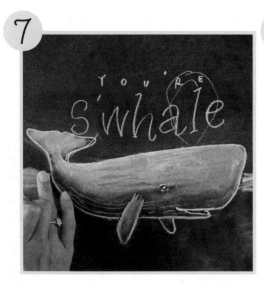

7 Add froth and waves to the surface of the water by smudging chalk along the horizontal line on top of the water.

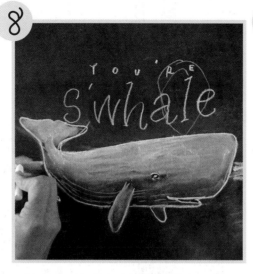

8 Using chalk, add light circular lines to give dimension to the waves on the surface.

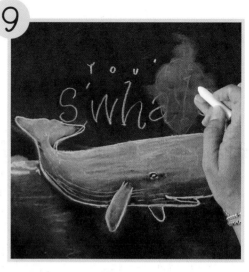

9 Using the remaining chalk dust on your finger, smudge out the area above the whale's head and blowhole.

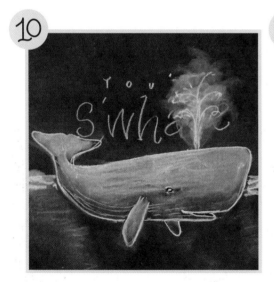

10 Draw in curls and arcs of chalk to give shape to the blast of water.

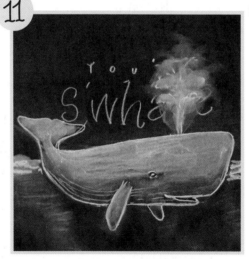

11 Lightly smudge the chalk; repeat until the water has the desired visual depth. (Don't make it too light or the letters won't stand out!)

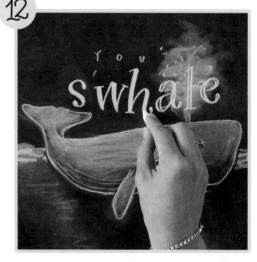

12 Pressing hard, rewrite the lettering above the whale. After drawing all the letters, use a pencil eraser to add a shadow and make the letters pop out from the rest of the piece.

the Craigs

EST 2012

BOBBY

DESIREE

WESTON

HARRISON

CHARLOTTE

Family Wreath

Berries

 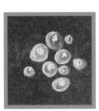

These berries are simple to make, and a beautiful way to fill space and add softness to your wreath.

To make the berries, draw a partially filled circle. Use your fingertips to smudge the chalk in the center of the circle. Last, add a rough "X" or star shape to the center of the berry. Group several berries together in your piece, just as you might find them in nature!

Pine branch

 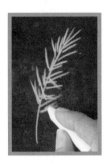 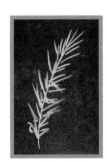

Draw a slightly curved line for the stem of the pine branch. Next, draw lines coming off of the stem that are heavier at the base and lighter at the ends. Add some variety to make the pine needles look more random and natural.

Leaf branch

 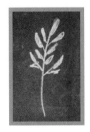 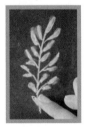 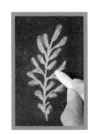

The soft oval leaves on the leaf branch provide relief from the sharp lines of the pine. Begin with an arched line, with an oval leaf right on the end. Add moderately colored-in ovals all down the stem, along with some offshoots slightly farther out. Once you have filled the stem, use your fingertip to gently smudge the leaves. Finally, thicken up the shoots and stem into the soft leaves with another layer of chalk.

To visualize overall layout placement on your chalkboard, begin by sketching out your stem lines, ribbon outline, and lettering.

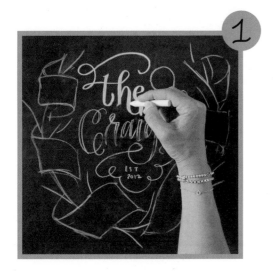

After you have sketched out the basic outline of your wreath and lettering, start at the top and finalize your lettering. Since you have the basic outline of your wreath, use flourishes on your letters to help fill in any remaining spaces.

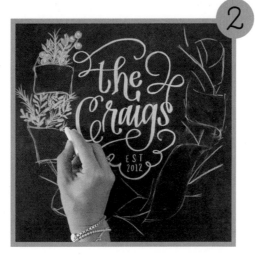

If you are right-handed, begin your wreath at the top left; if you are left-handed, begin at the top right. This helps to avoid smudging the design as you draw. Add three types of foliage, mixing them in each section of the wreath.

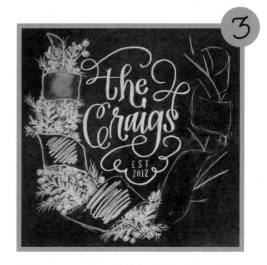

When you've finished half of the foliage, add shading to your ribbon by blending out your chalk with your fingertip. Keep the curved ends of the ribbon darker to make it look like it is wrapping around the back of the wreath.

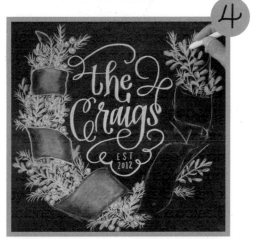

Complete the other half of the wreath from the top down. Fill in all of the spaces in the wreath with foliage. Make it look natural by having ends of the branches poking out in different angles to make it look like it is all being held together by the ribbon.

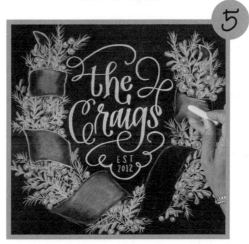

Shade the rest of the ribbon and the ribbon ends.

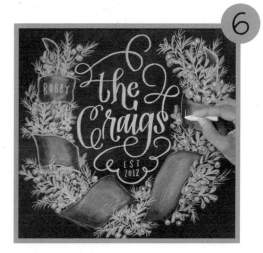

As a final step, add the names of your family members to the ribbon sections to make it even more personalized.

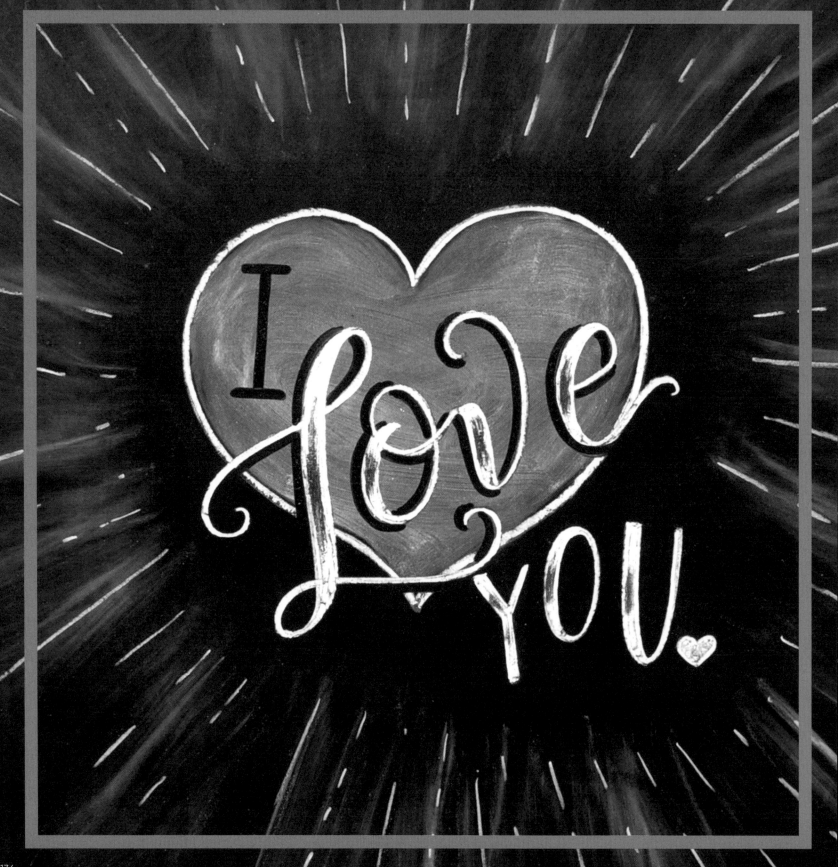

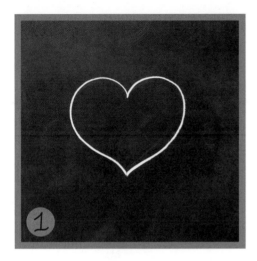

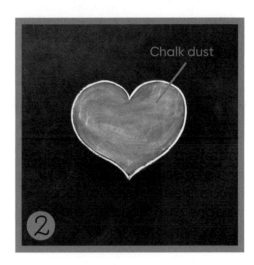

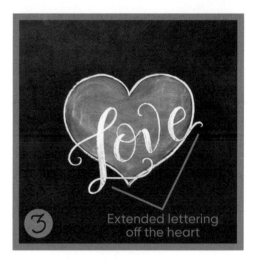

Step 1:
Begin by drawing a heart. Don't worry if the sides are not completely even.

Step 2:
Scribble the inside of the heart with chalk. Then use a felt eraser to "erase" the chalk and create chalk dust within the heart.

Step 3:
Write the word "love" in calligraphy across the heart. Some of the wording should extend off the heart and onto the black of your chalkboard.

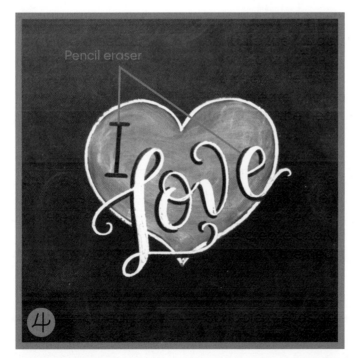

Step 4:
For this step, use your pencil eraser to write the word "I" in the upper left area of the heart. Next, use the pencil eraser to add shadow lines to the word "Love." In the example to the left, we added hard shadow lines to the left and underneath the lettering. Use a cotton swab to soften the hard shadow lines if you prefer a more blended look. By adding a shadow, the word "Love" stands out from the chalk dust. Be sure to add shadow lines extending off the heart with the lettering lines.

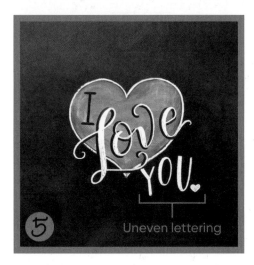

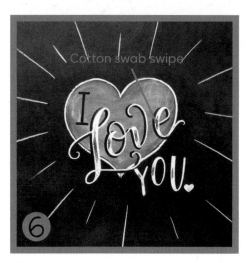

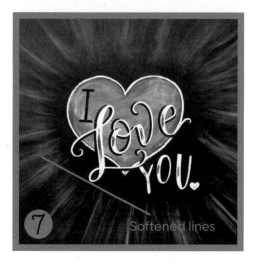

Step 5:
Add the word "You" to the lower right side of the heart. Writing the letters unevenly and sized differently will give the piece more character.

Step 6:
Use a cotton swab to lightly brush the middle of your letters to make them "shiny." Then, draw emanating lines on the outside of the heart.

Step 7:
Use a felt eraser to make outward strokes on the lines. This will make them softer and more natural looking.

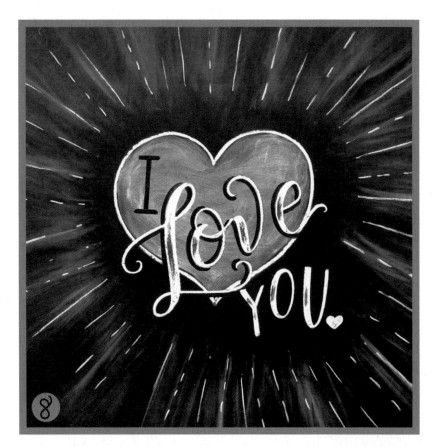

Step 8:
Once you blend and soften the line strokes around your heart, use chalk to add emanating lines around the heart once again. Feel free to mix up the line strokes. Add dashed or straight lines to make the final piece more visually interesting. The heart should appear as though it is glowing when you are finished. In Step 7, when you blended the emanating lines surrounding the heart, you created chalk dust on the surface of the board. This softened chalk around the heart gives the illusion that it is glowing, similar to how a star seems to glow in the night sky.

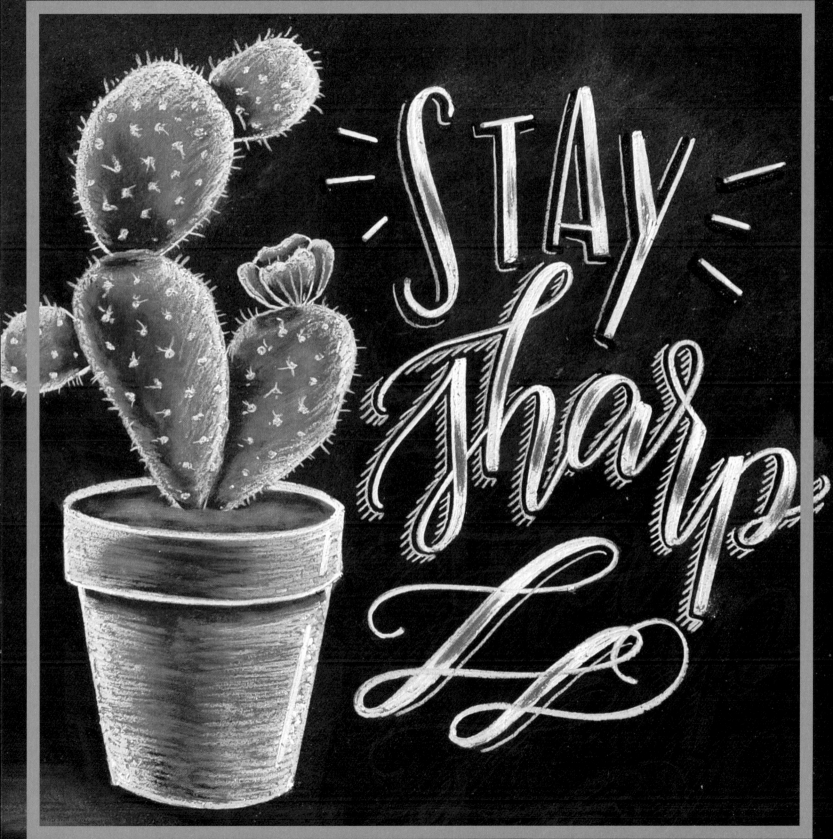

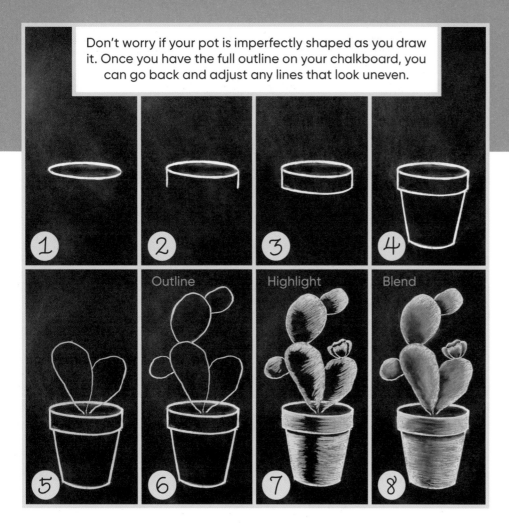

Don't worry if your pot is imperfectly shaped as you draw it. Once you have the full outline on your chalkboard, you can go back and adjust any lines that look uneven.

① ② ③ ④

⑤ Outline ⑥ Highlight ⑦ Blend ⑧

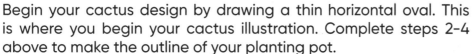

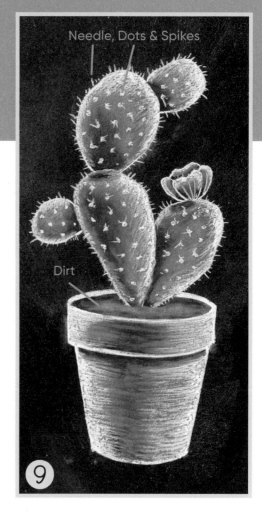

Needle, Dots & Spikes

Dirt

⑨

Begin your cactus design by drawing a thin horizontal oval. This is where you begin your cactus illustration. Complete steps 2–4 above to make the outline of your planting pot.

Next, add the outlines of your cactus as shown in steps 5–6. You can make yours look unique by adding uneven circles and shapes in various places as the cactus outline forms. Once you have a cactus outline that you are happy with, you can add details.

Imagine your light source location, and use chalk to add a highlight to every part of the cactus that light would hit (step 7). You can also add a highlighted cactus flower! Use your cotton swab, felt eraser, or fingertip to gently blend the highlight into the shadow to create a midtone color. As you blend, continuously add shadows, highlights, and midtones until you are pleased with the appearance of your design.

Complete your cactus by adding small, uneven dots all over. Then, go back and add light strokes to make cactus needles. Some needles should come out of the dots, and some should come from the sides of the cactus. You can also add some "dirt" in the planting pot. Finalize the small details in your design by adding highlights, midtones, and shadows as needed. Give the cactus flower some petal lines, and get ready to add the text to complete the design!

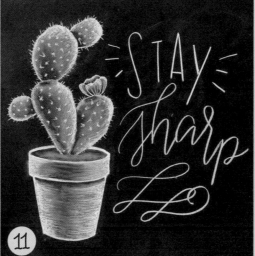

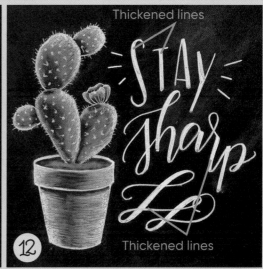

Thickened lines

Thickened lines

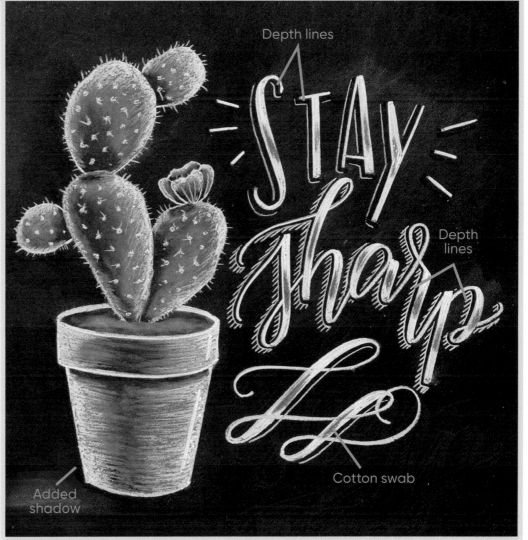

Depth lines

Depth lines

Cotton swab

Added shadow

Once you have finished your cactus illustration, you can add the text. For this particular design, we started with the word "sharp" followed by the flourish underneath (see step 10). We did this so that the word "stay" could be accurately placed above it. In step 11, notice how the "y" fits in the space between the "h" and "r" of the word "sharp". Once you have your basic letters down, you can go back and add more detail to them. In our example, the lines were thickened in both words, and depth lines were added to the left of the lettering. We also added slanted lines coming down from the word "sharp". Then, we used a cotton swab and lightly brushed the middle of each letter to give the illusion of shiny letters. Once the lettering was finished, a small amount of chalk dust and shadow were added to the left of the cactus image to complete the design.

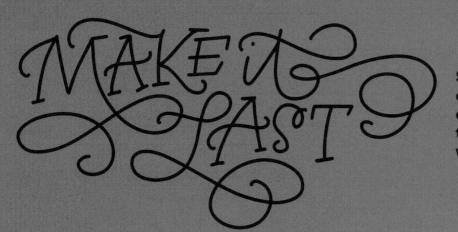

MAKE it LAST

Sometimes you make a piece that you don't ever want to wipe off! While most chalk creations are eventually erased, there are some instances when you will want to "set" your chalk.

To create chalk pieces that will stick around, there are two tricks that you can use: a chalk marker and hairspray!

Aerosol hairspray is a great option to "fix" or "set" your chalk art. When you apply a coat of hairspray, spray an extremely thin misting layer (or two) from at least a foot away from the chalkboard.

Warning: If the mist of the hairspray is not thin enough, the moisture in the spray may actually remove chalk marks (just like putting water on a chalkboard would). However, when the spray is light enough, the chalk dust will still be visible, but a light swipe over it with your finger won't ruin any of the design.

Before you apply hairspray to your final piece, do a practice mist on a sample chalkboard. You want to ensure that the hairspray coating is fine enough and that the moisture of the spray isn't too heavy.

A second way to create a more permanent design is with chalk markers. Not all markers are created equal; find one that gives good coverage. Once your chalk marker design is dry, you can go over the design a second time for a whiter, brighter design.

Chalk markers dry out easily. Ensure that the cap is tightly on your marker when it is not in use.

Since chalk markers do not erase easily, a pencil eraser is a useful tool to help remove any accidental lines or marks, edges, and corners. To remove your work completely, wipe off the marker lines with a damp cloth.

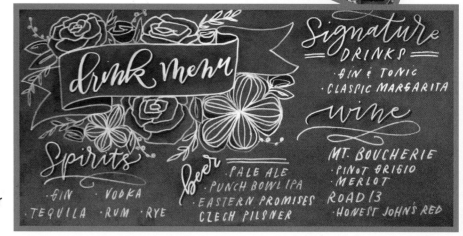

Using a chalk marker is a great option for chalk designs that you want to preserve and keep. Chalk pieces that are made for weddings, special events, and high-traffic areas in the home or workplace would all benefit from being created with a chalk marker.

CHALK MARKER PROJECT

1
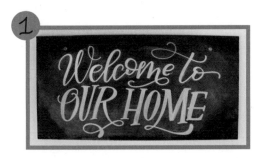

2

3

Step 1: Using regular chalk, lightly sketch the design for your final piece.

Step 2: Once your design is just how you want it, draw over the entire piece with a chalk marker, ensuring that your marker is achieving good coverage. Then, sketch in your decorative lines with chalk.

Step 3: Draw over the decorative lines with the chalk marker. Once the design is dry, use your microfiber cloth to wipe away the original chalk marks.

Step 4: Leftover chalk dust can remain on the board to add depth and visual interest that would otherwise be lacking. Use a pencil eraser to remove areas in the shadows of your letters or illustrations.

4

When pieces are created with a chalk marker or set with hair spray, they will be more resistant to damage, but they are not entirely safe. Treat your chalk creations with care and avoid touching the surface to maintain the integrity of the design.

Thank you SO much for learning to chalk with us! You made it! You have worked hard, practiced, and chalked your way through the lessons in this book. You're now ready to show off your illustration and lettering skills and to create your own stunning chalk art pieces.

Congratulations! We can't wait to see what you create. Be sure to use #Chalk101 on all of your chalk art!